SHOES

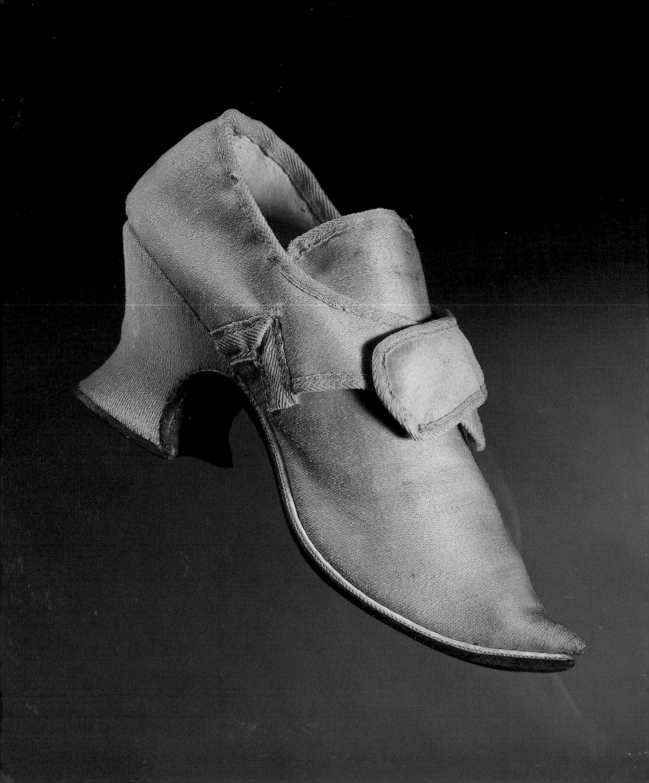

SHOES

Lucy Pratt and Linda Woolley

Colour photography by Sara Hodges

V&A Publications

First published by V&A Publications, 1999

V&A Publications
160 Brompton Road
London SW3 1HW

Lucy Pratt and Linda Woolley reserve
their moral right to be identified as the
authors

Designed by Broadbase
Photography by Sara Hodges;
V&A Photographic Studio

ISBN 1851772855

A catalogue record for this book is
available from the British Library

Manufactured in China by Imago
Publishing Limited.

Jacket front: Leather shoe
with medium heel, laced with
silk ribbon; British, *c.*1900.
Made by Hook Knowles & Co.
T.246–1997

Jacket back: Group of
women's flat 'slippers'. From
left to right: (a) Silk satin
slipper; British (London),
1825–50. Made by 'Borsley
Maker'. The silk ribbon ties
would have crossed over and
around the ankle. The toe is
square. 1152–1901 (b) Silk
satin slipper with a square
toe and matching silk
rosette; British (London),
1830s–40s. Made by W.
Reeve. T.503–1913 (c) Silk
satin slipper with a square
toe and matching silk
rosette; French, 1830s–40s.
This shoe was made for the
right foot: 'Droit 48/A' (Right
48/A) is written on the
insole. The insole of its pair
(not photographed) has
'Gauche 48/A' (Left 48/A).
Many slippers of this date,
however, were still made as
straights. T.273–1975

Frontispiece: Woman's shoe;
British (possibly Norwich),
1720s–30s. The latchets
were originally fastened over
the instep with a buckle. The
upper is covered in glazed
worsted and a similar, but
unglazed, material has been
used for the heel.
Circ. 511–1928

Contents

Acknowledgements

We would like to thank the following colleagues at the V&A for their help during the writing of this book: Linda Parry, Clare Browne, Paul Harrison, Amy de la Haye, Ngozi Ikoku, Valerie Mendes, Susan North, Debbie Sinfield, Jennifer Wearden and Helen Wilkinson of the Textiles and Dress Department; Avril Hart, Consultant for the British Galleries Project; Anthony North of the Metalwork Department; Shaun Cole, Charlotte Cotton and Susan Bright of the Prints, Drawings and Paintings Department; Lynda Hillyer, Marion Kite and Audrey Hill of the Textiles Conservation Department; and Clive Errington-Watson of Information Systems Services. The excellent photographs were taken by Sara Hodges, and we are also grateful to Ken Jackson, chief photographer of the V&A Photographic Studio.

We would like to thank the team at V&A Publications: Mary Butler, Miranda Harrison, Clare Davis, Geoff Barlow and Valerie Chandler. We are indebted to Kelvin Ithell of the British Library and Maria Flemington at Ham House. We would also particularly like to acknowledge the support of the following: Jim Roberts, Pamela Pratt, Richard Cross, Robert Chorley, Gus and Daisy.

Finally, we are very grateful to all the designers, donors and other individuals who have made this publication possible.

Opposite: Man's platform shoe, patchwork of snakeskin; British, 1972. By Terry de Havilland.
T.78A–1983

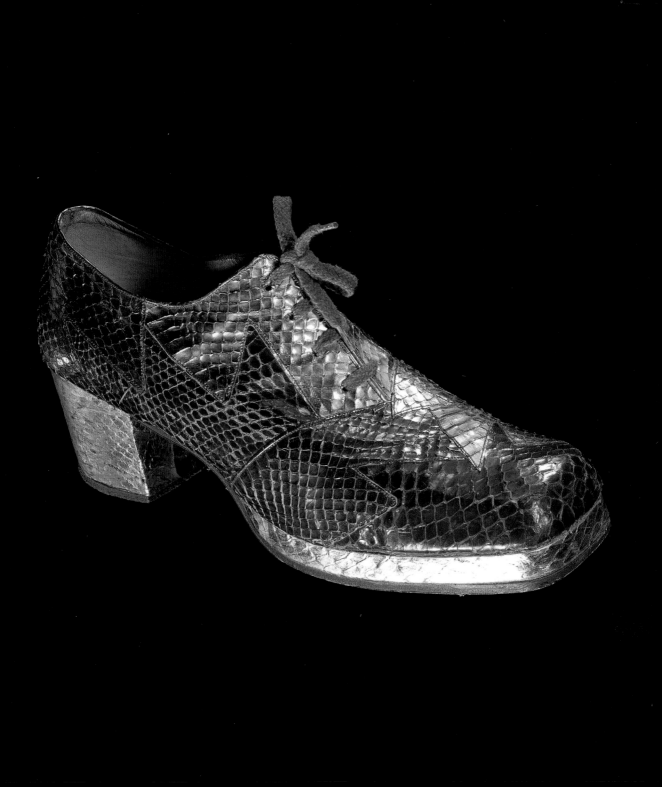

Introduction

I have spread my dreams under your feet;
Tread softly because you tread on my dreams.
(Excerpt from W.B. Yeats, *He Wishes for the Cloths of Heaven*, 1899)

Shoes are one of the most evocative areas of dress. Often beautiful and sculptural objects, they can be powerful indicators of the social and economic status of the wearer. The more elaborate and decorative, the less likely they are to be functional or easy to wear, and these very qualities have often resulted in their survival. Shoes have also been kept for aesthetic or sentimental reasons, and a number have survived by being buried, hidden or simply as an accident of fate.

Focusing on the V&A's outstanding shoe collection, this book explores the development of fashionable footwear from the Middle Ages to the present day. Women's shoes are better represented than men's because these have tended to survive in greater numbers. Some examples are included because of their extraordinary design or links with a particular moment in history, while others show how technical developments have altered methods of construction, resulting in new shapes and styles.

Whether fashionable or functional, the shoe has excited as much comment in the past as it does today. The toes of medieval poulaines grew so long and pointed that laws were passed to limit their size, while women who staggered on chopines – the Renaissance equivalent of the platform sole – were compared to Venetian prostitutes. The beauty of the foot has also been admired. Richly embroidered mules of the seventeenth century and delicate Georgian shoes sought to enhance an elegant ankle or complement the clothes with which they were worn. In the early Victorian era, shoes became so restricting that writers complained of how women were prevailed upon to 'pinch' their feet into tiny satin slippers. Less extreme and more comfortable designs have also made an impact. A simpler style of shoe was adopted during the French Revolution in keeping with the ideals of equality,

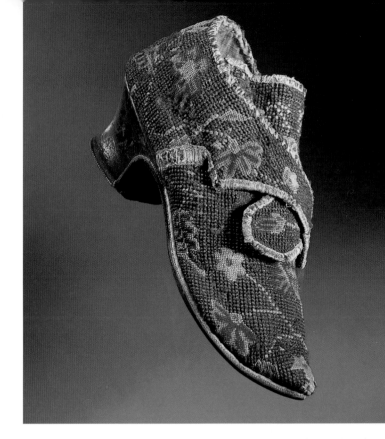

Plate 1 above Woman's
shoe; British, 1730s–40s.
As in the Frontispiece
latchets were originally
fastened over the instep with
a buckle. The canvas upper
is embroidered in brightly
coloured wools and the front
of the sole is bound with
vellum. T.117–1933

and by the end of the nineteenth century the growing popularity of sports encouraged a more practical approach to footwear.

The twentieth century witnessed the rise of the designer shoemaker. During the 1920s and 1930s names like Salvatore Ferragamo, André Perugia and Roger Vivier focused the eyes of fashion on jewel-encrusted heels, chunky wedge soles, surrealistic shapes and startlingly sleek silhouettes. The designer shoemaker continues to make an impact. Exploring elements from the past, combining traditional craftsmanship with technological advances and uniting function with art, contemporary designers have created innovative styles which continue to inspire and often surprise. In this book, creations by Vivienne Westwood, Jimmy Choo, Patrick Cox, Christian Louboutin, Armando Pollini, Oliver Sweeney and Manolo Blahnik suggest that shoes of the 1990s will shape the future of footwear design into the millennium and beyond.

Chapter One

Medieval Gothic and the English Renaissance

Sum men sayd that they wolde wear long pykys [pikes] whether Pope wylle or nylle, for they sayde the Pope's curse wolde not kylle a flye.
(Anonymous writer, continuation of William Gregory's *Chronicle of London*, 1468)

Shoe Fashions in the Middle Ages

Fashions in shoes for the wealthy seem to have changed in the Middle Ages as quickly as they do now, according to material excavated by the Museum of London covering the period of about 1150 to 1450. This is one indicator of the immense importance of textiles and dress in a period when there were few luxury goods available; status and class could be demonstrated by colourful and stylish clothes as well as furnishings and hangings.

Textiles and dress, particularly at the luxury end of the market, were very expensive and the outlay for them constituted a far greater part of a wealthy person's income than it would today. It has been suggested that the large market in the re-making and repair of old shoes may have been one of the main sources of cheap shoes for the poor, almost all of whom seem to have worn footwear of some kind. Shoes are among the articles of dress frequently cited as bequests to the church, as donations to monasteries for example.

Medieval shoes, like all early clothing and accessories, survive only in small numbers and often in very poor and fragmentary condition. Only the sturdiest of footwear remains from this period – except in an ecclesiastical context – leaving us with little evidence of the range of materials available, which originally included leather, cloth and silk. The majority of excavated shoes are made of leather which, given certain conditions, lasts better than most textiles. Although such shoes

may retain their original shape they are generally dark and dirty, revealing little of the nuances of colour and the stylishness which may have characterised them when they were made.

Stylistic changes, some made possible by technical advances in shoe-making, can be defined by such features as the height of the quarters, the manner of fastening, the shape of the toe and, more rarely, the addition of some form of decoration. Sometimes hose were fitted with a leather sole, obviating the need for a separate shoe, and this presumably acounts for the many contemporary illustrations in which people appear to be unshod.

Throughout the period shoes were flat, but toe shapes varied from rounded to very pointed. Ankle boots sometimes predominated, while at other times shoes were favoured; style seems to have varied regionally as well. Buskins, a form of long boot, were worn for riding. Long boots were also fashionable footwear in the second half of the fifteenth century. Fastenings included lacing, buckles and latchets. One major change in construction, which made shoes slightly more comfortable, occurred in the late twelfth or early thirteenth century, when the shaped or 'waisted' sole was introduced. The shaping of shoes to fit the left and right foot, from as early as the twelfth century, and the use of good quality, supple leather also contributed to making footwear fit the contours of the foot more closely. In the late fourteenth century, openwork decoration or engraved patterns were introduced.

The Cordwainers

The guild of shoemakers was one of the earliest in England, issuing its first ordinance in 1272. It was called the Guild of Cordwainers, a name taken from a corruption of Cordoba, the town in Spain from which the best leather, *Cordovan,* came. The Guild was originally established in London's Cordwainer Street. In the Middle Ages cordwainers disputed with cobblers about the latter's use of pieces of new leather in the re-making of shoes. New leather was thought by the cordwainers to be for their use only, and for making new shoes.

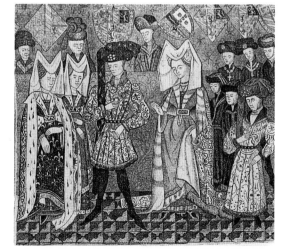

Fig. 1 below Facsimile from a 15th–century manuscript, showing a court scene with a man wearing fashionable poulaines. Source unknown.
E.1278–1888

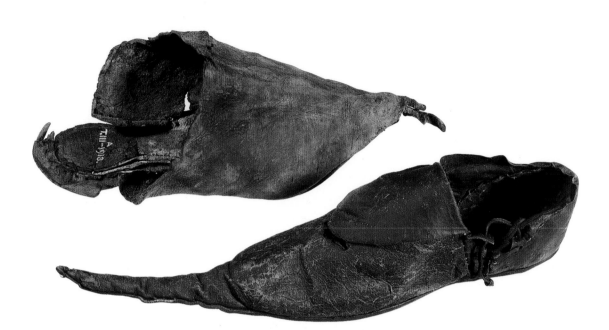

Plate 2 above Men's poulaines. Top (a): Part of a leather poulaine; English, 1370–1400 or 1450–1500. The back part is missing and the method of fastening difficult to determine, so a precise dating is impossible. T.111–1918
Bottom (b): Copy of a 15th-century poulaine; Spanish, 19th century? Considered to be genuine at the time of acquisition, this shoe is now thought to be a very good fake. It was reputedly found in the rafters of a house in Toledo. T.391–1913

The Poulaine or Pike

By the last quarter of the fourteenth century, shoes with pointed toes predominated, reaching their extreme in the much commented-on and derided 'poulaine' or 'pike' (fig. 1 and plate 2). This long, pointed medieval shoe is also known as the 'cracow' after the important cultural centre of Krakow in Poland, to which its origin is sometimes attributed. The poulaine was worn by priests as well as laymen and in *Piers Plowman* (*c*.1377), William Langland describes 'vain priests in the company of the Anti-Christ' as wearing 'pyked shoes'. Shoes with the longest points were cut low on the instep and fastened with buckles or latchets. The toe length could be of in excess of 4 inches (10cms), and was normally stuffed with moss or hair which had the twofold effect of keeping the toe straight and of raising the end off the ground, making it marginally easier for the wearer to walk.

There is a charming but probably apocryphal notion that there were pikes or poulaines which were tied right up to the knee (or even the waist) with laces or chains. One of the two written sources cited as evidence for this, the late fourteenth-century *Eulogium Historiarium,* seems to have been misread and regrettably no shoes of this type survive to prove this form of fastening existed, although they are sometimes shown in manuscripts.

The poulaine was popular from about the 1370s to 1400. The fashion was revived in the mid-fifteenth century and became subject to a sumptuary law passed in 1463 in the reign of Edward IV, which stated 'that no knight under the state of a Lord, Esquire, Gentleman nor other person should use nor wear in any Shoe or Boots having pikes passing the length of Two Inches...'. As with all extremes of fashion, the very long poulaine was not standard footwear but worn by a fashion-conscious minority. Styles for women were basically similar to those of men, but without the extremes. Wearing very long pointed shoes as well as walking in long skirts must have largely precluded the wearing of poulaines by women.

The adoption of sumptuous clothes and ostentatiously fashionable shoes reflected the growing wealth of the middle classes. For example, poulaines dating from the fourteenth century have been found in France, which like England was becoming increasingly prosperous at that time. In Amsterdam, however, no poulaines have been found dating from earlier than the late fifteenth century, which coincides with the date of the city's prosperity.

The fashion for shoes with pointed toes, in keeping with the spiky, vertical lines characteristic of fashionable dress in the late Gothic period, had died out completely by 1500.

Pattens

Pattens – wooden-soled overshoes to protect the feet in mud and snow – were in use in the fourteenth century but were apparently restricted to the wealthy. By the early fifteenth century the introduction of a new, cheaper form of patten, which had a composite leather sole and may have been worn without a shoe, made them more widely accessible.

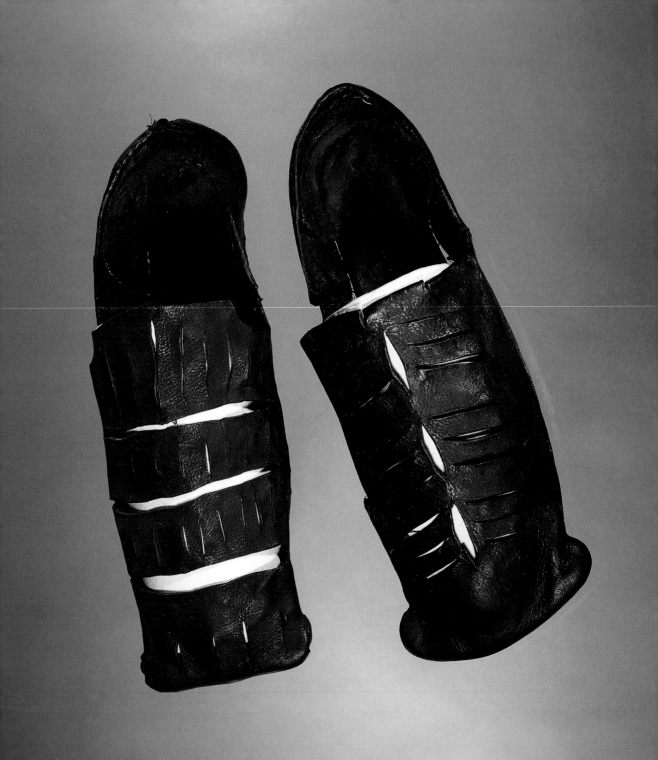

The Renaissance

The spirit of the Renaissance changed political, social and intellectual attitudes, with a different distribution of wealth following the rise of a rich and powerful bourgeoisie who competed with courtly circles in the world of fashion. The emphasis in fashion for men changed from the vertical line of the Gothic period to the horizontal, and this is very noticeable in the case of the shoe.

Many of the aristocrats at the court of Henry VIII (reigned 1509–1547) had acquired wealth through the confiscation of church property during the Reformation, and wanted their dress to project a powerful image. Wealth and physical strength were demonstrated in clothes made of sumptuous imported materials, with wide shoulders and massive padding across the chest. Initially, in the early sixteenth century, the toe changed from pointed to a sensible, broader shape which was fashionable with the wealthy merchant classes. The style became much more exaggerated during the reign of Henry VIII with some soles being more than $6^{1}/_{2}$ inches (17cms) wide. These extremely wide shoes, like the extremely pointed shoes of the previous century, fell under the stricture of sumptuary legislation.

A distinctive style popular in the 1530s and worn by Henry VIII was the lower cut shoe with a strap across the ankle, usually with a buckle, and a square or 'horned' toe (plate 3).

The famous portrait of Henry VIII (1539, school of Holbein), in Chatsworth House, Derbyshire, shows the king in typical aggressive and self-confident pose, feet planted apart (fig. 2). The slashing of his silver brocaded doublet is echoed by the slashed white or cream silk of his square-cut shoes. Silk or velvet shoes were fashionable formal wear, reflecting the popularity of these materials, which were principally imported from Italy. Due to their fragile nature examples have not survived, but the style seen in the portrait survives in the leather shoes shown in plate 3.

Another style of broad-fronted shoe known as the 'high shoe' was so formless that there was no point in having a distinction between the right and left foot. Such shoes were known as 'straights'.

According to French tradition, Charles VIII of France (reigned 1493–98) had six toes on each foot and special shoes were made for

Plate 3 Slashed leather men's shoes (not a pair); English, *c.*1510–30s. Found in a Plague Pit in London. T.412–1913; T.413–1913

him with wide ends. It is possible, therefore that a congenital royal deformity started the new fashion.

Shoe Decoration

The vogue for puffs, panes and slashes characterised the dress of Henry VIII and his court, which vied for supremacy in fashion with the court of the French king, Francis I (reigned 1515–47). Slashed patterns in shoe uppers, with vertical, horizontal and diagonal cuts through which the brightly coloured lining could be glimpsed, reflected this fashion. The slashing also softened the solid appearance of leather, while making the shoes more supple. It may have derived from Swiss mercenaries, who incorporated the slashing as a form of decoration in imitation of the sword slashes their clothes received in battle. In France, slashing on shoes was attributed to the need to accommodate the bandaged, wounded feet of Francis I's soldiers, who fought in the Italian wars. The Germans took up this look with particular fervour, and other nations, including England, copied it in a less extravagent way.

During the 1540s there was a return to a more natural, rounded or almond-shaped shoe, which continued beyond the end of the century. Slashed decoration also remained popular. In a famous portrait in Hampton Court Palace by an unknown artist (c.1540–48), a young man dressed all in red, except for a shirt with blackwork embroidery, wears red silk or velvet shoes with rounded toes, cut high at the ankle, slashed diagonally, and studded with jewels.

Women's shoes

Women's dress was less flamboyant during this period, although embroidery and slashed decoration were favoured. Women wore similar shoe styles to men, presumably following male fashions. A charming portrait by Holbein (c.1540), in the Ashmolean Museum, Oxford, shows a woman wearing square-toed shoes cut low at the front and sides, with a strap fastening across the instep.

The 1554 inventory of Queen Mary Tudor (reigned 1553–58) included payments for the making of 38 pairs of velvet shoes lined with satin and with scarlet soles, two pairs of buskins and three pairs

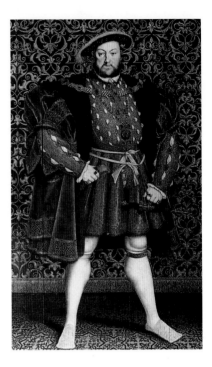

Fig. 2 above Portrait of Henry VIII. School of Holbein, c.1539. Several portraits show the king in this characteristic stance. Said to have been copied from a fresco formerly in the Palace of Whitehall. The Devonshire Collection, Chatsworth. Reproduced by permission of the Chatsworth Settlement Trustees: photograph Courtauld Institute of Art

of velvet slippers lined with scarlet. Boots were not fashionable wear for men or women at this period and the buskins listed here were presumably used for riding. It is evident from these entries that huge quantities of shoes were made for the rich and powerful at this time. These were mostly in luxury materials which were not durable, and this is even more vividly demonstrated in the case of Queen Elizabeth I's wardrobe.

The Reign of Queen Elizabeth I (1558–1603)

'When your Posterity shall see our picture they shall think we were foolishly proud of apparell', wrote R. Verstegen in *Antiquities Concerning the English Nation* (1605). Queen Elizabeth, like her father before her, indulged in what in modern terms would be called power dressing. Her portraits bear witness to the sumptuous array of clothes and jewels she owned. For the first twenty-two years of Elizabeth's reign, Spanish fashion, which had prevailed since the marriage of Mary Tudor to Philip II of Spain in 1554, continued to influence the shape of English dress. However, the decoration and exaggeration of certain features were uniquely English.

Men's dress lost the assertive shape which it had acquired during Henry VIII's reign. Shoes retained the more natural, rounded or oval-shaped toe which fitted in well with the romantic, almost feminine look of clothes, such as pointed doublets and padded trunk hose which emphasised the hips.

In *Queen Elizabeth's Wardrobe Unlock'd* (1988), Janet Arnold details both the materials available and the changing styles for the wealthy which were favoured during Elizabeth's long reign. Until 1564 all Elizabeth's shoes, like those cited in Mary Tudor's inventory, were made of velvet. By contrast, one of her servants, Ippolyta Tartarian, had only leather shoes. In 1562 she was given twelve pairs of leather shoes, two pairs of Spanish leather shoes, and one pair of leather pantobles.

Elizabeth had her first pair of leather shoes made in 1564 and in 1565 another three pairs. By 1575 more leather than velvet shoes were made for the queen: 'for xxiiij paire of velvett Shoos Slippers and Pantobles stitched wtih silke Lined with satten and in the Soles with

skarlett two paire of Slippers of Tufte Taffata lyned with velvet, xxxiij paire of Spanish lether shoes and pantobles of sondrie colours and fashions'. This seems to have been an early example of fashions filtering up through the classes rather than down.

Although the queen's favourite colours were black and white, her leather shoes were made in a wide range of colours, including tawney orange, green, white and 'ashe', and her velvet and satin shoes included colours such as black, crimson and 'murrey'. As well as making new shoes, the queen's shoemakers 'translated' or re-made old shoes. There are also references to pinking, embroidery and the 'perfuyming' of her shoes by a man called John Wynneyard in 1572.

Terminology

Shoe terminology is often confusing, especially when the words describing a single style have varied linguistic origins. Additional complications occur at a time when terminology in documents was inconsistently spelt and clerks no doubt had their own idionsyncracies in recording items. The terms mule, pantoble (variously spelt) and chopine (also variously spelt) all describe forms of backless shoes or slippers. Writing in 1589 in the *Art of Poesie,* George Puttenham referred to: 'these high corked shoes or pantoffles [pantobles] which now they call in Spain and Italy shoppini [chopines]'.

It was never noted that Elizabeth I had mules in her wardrobe, although her servant did have mules made, and Janet Arnold has suggested that the terms mule and pantoble were probably interchangeable.

In 1591, Peter Johnson made the queen three pairs of pantobles 'of the new fashion layed on with silver lace'. The new fashion perhaps refers to arched heels or to open toes, as he also made 'two paire of Spanyshe lether pantobles open at the Toes, laid on with silver lace'. It is possible, therefore, that the chopines seen in plate 5, which have trimmings of

Plate 4 below Kid leather chopine; Italian (Venetian), *c.*1600. Mounted on wood with decoupé decoration and figured silk underlay.
T.48A–1914

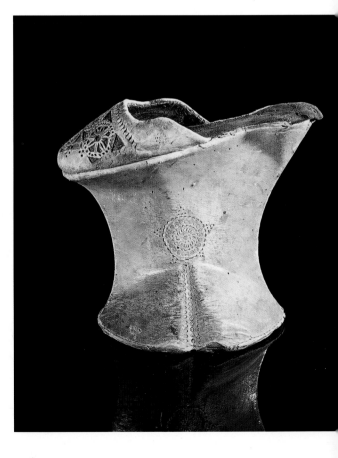

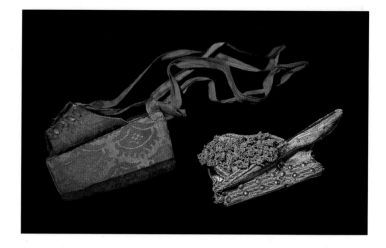

Plate 5 right Left (a): Cork
chopine; Spanish, late 16th
to early 17th century.
Covered with 17th-century
silk damask (possibly added
later). Stamped decoration
on the insole. T.419–1913
Right (b): Wooden chopine;
probably Venetian, c.1600.
Covered with velvet and
trimmed with silk ribbon and
gold lace. Stamped leather
decoration on the insole. The
upper is divided with holes
for lacing, suggesting that
the gold lace may have been
added slightly later, although
lace of this type was found
in the late 16th as well as
early 17th century. 929–1901

gold lace, may be similar to the queen's pantobles. The origin of an embroidered chopine or pantoble of about 1600, now in the Ashmolean Museum, Oxford, is thought to be Italy or England.

The Chopine

Like the poulaine, chopines were the subject of satire and of moral censure by the church. They are condemned as early as 1438 by a priest in Spain, mentioned in the second act of Hamlet and, as late as 1653, derided by Dr John Bulwer in *Artificial Changeling:* 'What a prodigious affectation is that of chopines where our ladies imitated the Venetian and Persian ladies'.

The chopine was one of the most extreme and artificial styles of footwear ever created. A fairly modest example is shown in plate 4. It could reach a height of over 18 inches (50cms), but this extreme seems to have been confined to Italy and possibly Spain. It probably originated in Venice and was first worn by prostitutes, but was then adopted by fashionable Venetian aristocrats. The style derived from the Turkish bath shoe which kept the feet of the wearer out of the water. In a painting by Vittore Carpaccio (*c*.1495–1500) in the Correr Museum, Venice, two seated courtesans wear chopines – concealed by their dresses but clearly visible in outline – which look as big as dinner plates. The chopine was originally a form of overshoe, but the

modified later versions could be worn as either over-shoes or on their own. Sometimes Elizabeth I had pantobles (chopines) made to match her shoes, but they are also listed separately which suggests that she may have worn them without a shoe inside. This illustrates the development of an originally utilitarian item of dress to one purely of fashion.

Although a small number of chopines survive from the late sixteenth to the early seventeenth century, very few other types of fashionable shoe survive from this period, particularly in England. However, the Ashmolean Museum in Oxford has an example of a pinked white leather shoe with a heel and latchet fastening of about 1600 (fig. 3), and Queen Elizabeth I can be seen wearing a pinked shoe in portraits of the 1590s.

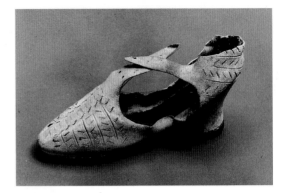

The Development of the Heel

The general trend in Elizabeth's reign for both men's and women's shoes was towards a narrow bluntly pointed toe and a gradual increase in the thickness of the sole. During the last quarter of the century the latchet fastening began to replace the slip-on type of shoe.

The development of the shoe with heel and arched sole, which was to be a central feature of seventeenth-century fashionable footwear, began in the sixteenth century. It developed from the wedged shoe and the chopine. Examples with arched wedges, which date from 1545, were found on the wreck of the Mary Rose ship. High heels and arches are not mentioned in Queen Elizabeth's warrants until 1595. In *Queen Elizabeth's Wardrobe Unlock'd,* however, Janet Arnold cites a reference by June Swann to a monument to Mary Carewe in Hascombe Church in Devon, dating from 1589, which features a shoe with a curve up under the arch.

Queen Elizabeth I is shown in an engraving of *c.*1593–95 wearing wedge-heeled shoes. In 1595, Peter Johnson made the first pair of shoes for her described as having high heels and arches. These probably had heels made of wood like those requested by Dame Margery in *The Shoemaker's Holiday* by Thomas Dekker, 1599: 'Prithee, let me have a pair of shoes made; cork, good Roger; wooden heel too'.

Fig. 3 above White suede girl's shoe; English, *c.*1600. Large open sides and latchet fastening for ribbons; pinked and slashed decoration. The lower pair of lace holes on the tongue were for a decorative rose. Ashmolean Museum, Oxford

Chapter Two

Heels, Buckles and Bows: The Seventeenth Century

All repute

For his devices in hansoming a sute,

To judge of lace, pinke, panes, print, cut and plight,

Of all the Court, to have the best conceit.

(John Donne, *Satyres, Epigrams and Verse Letters,* ed. W. Milgate 1967)

James I (reigned 1603–25)

The early years of the seventeenth century saw considerable growth in trade, including that in luxury goods such as silks and lace, and a relative economic stability in spite of growing political and religious division. However, James I's court, unlike that of Elizabeth I who had kept a tight reign on her courtiers, was riddled with scandal and disorder and dominated by James' posturing favourites.

The Jacobean fop was narcissistic and spent vast sums on his wardrobe. With a more pronounced emphasis on the leg, both stockings and shoes became elaborate and colourful and played a far greater role in fashion than previously. Decoration by slashing along the uppers to show the stocking or coloured shoe lining continued until about 1615.

The Heel

The development of a proper heel with an arched sole was the dominant feature of shoes in the seventeenth century. It completely altered the posture of the wearer, encouraging both men and women to carry themselves in a way which set off the flowing lines and affected manner of the Baroque period. The raised heel was at first low and rounded but was to grow to a height of two to three inches, with a square base made of leather or wood.

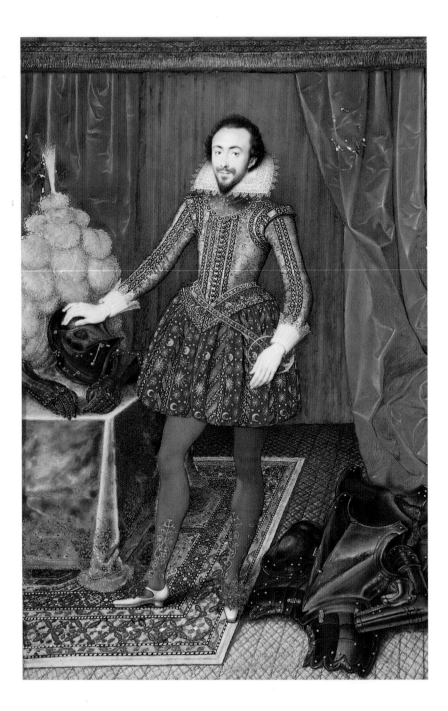

Plate 6 left Miniature of
Richard Sackville, 3rd Earl of
Dorset. Isaac Oliver, 1616.
Sackville was described
as a 'licentious spendthrift'
and had a vast wardrobe.
His shoes have the
contemporary fashionable
heel, large side openings
and large exotic gold rose.
721–1899

All shoes were now made as 'straights', which June Swann has suggested was due to the technical complications of making mirror-image lasts which would differentiate right from left for shoes with heels.

The Toe

The rounded toe continued to be fashionable for the first decade or so of the century, but between 1610 and 1620 the square toe began to dominate and remained fashionable to the end of the Cromwellian period, that is, until about 1660. Portraiture was popular in the seventeenth century and, together with engravings, literary references and other documentation, provides a great deal of information about fashion, including footwear, which is particularly invaluable where no examples survive. William Larkin's portrait of Lady Dorothy Carey (*c*.1614), in Rangers House, London, depicts her wearing white shoes with blunt toe, medium high heel, large open sides and latchet fastening obscured by a large gold rose. Such shoes were worn by both men and women, and in 1618 the Chaplain to the Venetian Ambassador in London commented that ladies attending the masques 'all wear men's shoes (or at least very low slippers)'.

Latchet Fastenings, Ribbon Ties and Roses

Shoes with latchet fastenings had begun to replace the slip-on shoe in the last quarter of the sixteenth century and continued into the seventeenth century. The ribbon ties fastening the latchets over the tongue grew large enough to become decorative features in themselves, and large bows or rosettes began to adorn the front of the shoe.

From about 1610 magnificent court roses, such as those seen on Lady Dorothy Carey's shoes in the portrait mentioned above, were very fashionable. In *The Devil's Lawcase* of 1618, John Webster refers to 'overblown roses to hide your gouty ankles'. A wonderful portrait of Richard Sackville dated 1613 and, like the Carey portrait, now in Rangers House, London, is attributed to William Larkin and shows Sackville wearing shoes with a huge rose and embroidery matching that of his doublet. The shoes are very similar in style to those worn by Lady Carey in Larkin's portrait of the same period.

A miniature of Sackville (plate 6), dated 1616, shows him wearing a

less elaborate, but still very fashionable outfit. The blunt, almost square-toed shoes have wide side openings, which were a notable fashion feature at this time for both men and women. The large gold roses adorning the shoes are typical of the period and could be very expensive. They are listed as separate items in Richard Sackville's inventory, which included '59 item one paire of Roses edged with gold and silver lace' and '110 item one paire of greene Roses edged with gold lace'.

Charles I (reigned 1625–49)

Dress became more refined during the reign of Charles I. Braid and lace replaced the cruder decorations of slashing and paning, and the display of jewellery was less ornate. At the same time, France became the fashion leader in Europe and superceded Spanish influence, although England modified French style to suit its own national taste.

Men's footwear, not surprisingly, was considerably influenced by military dress, since this was a period of unrest and warfare through-out Europe, including the Civil War in England (1642–49).

The knee-high boot dominated footwear in the reign of Charles I, and from about the 1620s to the 1690s it was fashionable for both indoor and outdoor wear. A portrait of about 1618 (School of van Somer), housed in the Tower of London, shows Charles, then Prince of Wales, wearing white knee boots with turn-down top, a blunt-pointed toe and low heel, in soft, slightly wrinkled-looking leather, with spur and spur leather. This wrinkled look was already much admired, as confirmed by the *Return from Parnassus* of 1606: 'One that more admires the good wrinkle of a boot, and the curious crin-cling of a silke stocking'. Fashionable boots could be made to look extremely decorative and elegant, and were very costly.

Charles I had twenty pairs of riding boots made in 1634–35, which cost the large sum of £24. The wide range of items listed in Philip Massinger's play of 1632, *The City Madam,* illustrates the comparative costs of such boots with the shoes for a poor man: 'a pair of shoes for the swineherd...cost 16 pence'.

Unless strictly for practical use, fashionable boots were made of fine supple leather to give an easy fit around the leg. They were made very

Fig. 4 above Portrait of Henry Rich, 1st Earl of Holland. Studio of Daniel Mytens, *c.*1632–3. The soft wrinkled leg boot was fashionable aristocratic wear in the reign of Charles I. The boot has a decorative butterfly spur leather and a lace trim at the knee. Flat goloshes were worn over the boots to add protection. National Portrait Gallery, London

long but were turned over below the knee, either in a double fold or in a cup or bucket shape. In the 1640s bucket tops became very wide, and when turned down fell almost to the ankle. Heel spurs were attached to the foot by large, butterfly-shaped spur leathers which covered the instep. Boots were also lined with inner boothose to protect the stockings from the rough or greasy surface of the leather. The tops of the boothose appeared above the boots and were usually trimmed with a border of lace or embroidery (fig. 4), focusing attention on the knee as roses (worn at the knee as well as on the shoe) had done earlier in the century.

More functional and heavy jackboots, made of hard black leather, were worn for fighting. A few examples of such boots survive, including an example in the Northampton Museum with blocked toe and turned-over top.

There is, however, little evidence that this fashion for boots so widely embraced by men affected women's footwear and, as previously, women wore boots only for riding.

Chimney Shoes

Shoes are often associated with good luck, and although it is still not entirely clear why, they are often found concealed in buildings – a practice which has continued for centuries. They were thought to ward off evil spirits, or at least in some way to keep the building and its occupants safe and lucky. Usually concealed in the chimney but sometimes in the rafters or under the floorboards, this hidden footwear has been a particularly fascinating source of information. The shoe seen in fig. 5 is likely to have been found in a chimney, judging by its blackened appearance. Its blunt toe, small side opening and latchet fastening for ribbon ties suggest a date of the 1640s to 1650s. Probably not an example of high fashion wear, although it has fashionable features, it is a sturdy shoe for outdoor wear. Its well-worn state could indicate that it was working-class country wear. It relates closely to a 'chimney shoe' of about the same date in the Northampton Museum, which came from a house in Stowmarket, Suffolk. The poulaine shown in plate 2b is

reputed to have been found in rafters in a house in Toledo in Spain, and thus may be another example of the phenomenon of footwear concealed to protect a property and its occupants.

Mules and Slippers

Mules (later in the century referred to more often as 'slippers') continued to be fashionable for both men and women throughout the seventeeth century. Surprising numbers survive, principally from the second half of the century, perhaps because they were not subject to the hard wear of other shoes.

A man's mule (plate 7), now sadly faded from its original salmon pink – a particularly fashionable colour in the seventeenth century for both men's and women's dress – is the earliest seventeenth-century example in the V&A's collection. The pronounced square toe and heel shape suggest a date of the 1650s. Silk and velvet mules and shoes were very fashionable. They were often embroidered, reflecting the vogue for domestic embroidery which burgeoned in the second half of the sixteenth century and throughout the seventeenth century. After the Reformation, when ecclesiastical embroidery had ceased to be required for the church, embroidery came into its own in dress and furnishings, as the middle classes spent money on both building and furnishing their houses and on lavishly embroidered clothes. Interestingly, surviving mules from the seventeenth century do not reflect the great interest in naturalism in England, being generally embroidered with stylised patterns in metal thread. It may be due to the slightly more durable quality of metal thread that these have survived rather than lighter weight mules of silk with silk embroidery, although it is possible that the latter was considered too flimsy to be used even for shoes for indoor wear.

Both women's and men's shoes had moderate or high heels, and a velvet mule (plate 8) with medium heel and square, slightly over-hanging toe is a typical example of luxury indoor wear for women of about the 1650s to 1660s. A similar mule of embroidered velvet, which was worn by Queen Henrietta Maria, in the collection of Northampton Museum, is dated to between 1660 and 1665. It has a slightly higher and narrower heel and the addition of a woven strip round the top.

Fig. 5 above 'Chimney' shoe of darkened brown leather; English, 1640s–50s. Very worn, perhaps belonging to a working-class woman. Has fashionable features of side opening, blunt toe and latchet fastening for ribbons.
692–1897

Plate 7 above right Watered
silk man's mule, originally
pink; English, 1650s–60s.
193–1900

Plate 8 right Velvet mule
for a woman; English,
*c.*1650s–60s. Embroidered
in couched and raised gold
thread. T.631–1972

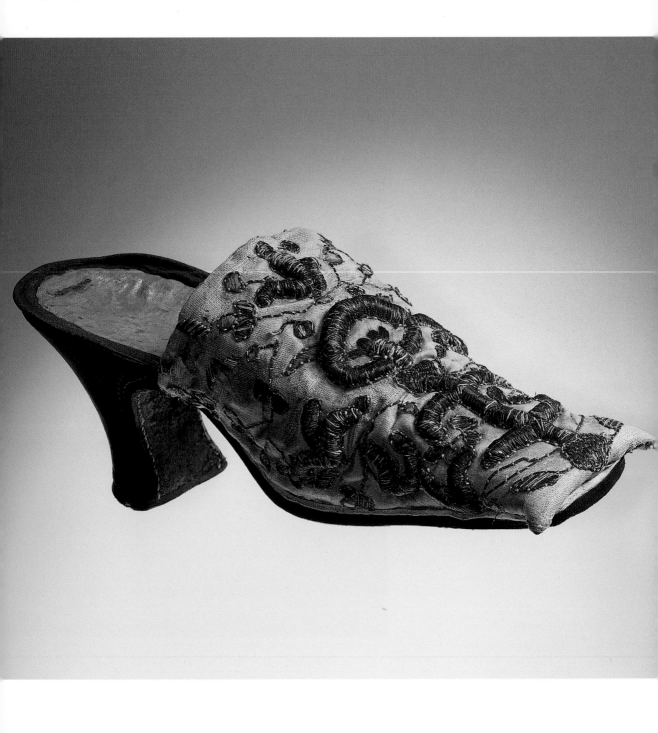

Both mules have white kid rands (narrow strips of leather) which became a distinctive fashion feature of women's shoes from this time until about the 1760s. Prior to this date darker, inconspicuous rands had been used.

The forked toe, fashionable from the 1660s to 1680s, may be seen as a more elegant, modified version of the sixteenth century 'horned' toe. A small number of examples survive, including the woman's mule in plate 9. Randle Holme's *Academy III* of 1688 records that 'Shoes according to the fashion of the Toes or Noses are sometimes round, others square, then forked, and others turned up like a hook'.

The Restoration and the Influence of French Fashion

The introduction of French fashions for men coincided with the return of Charles II to England in 1660, and the subsequent restoration of the monarchy. Louis XIV (1643–1715) had made Paris the capital of the civilised world and, given Charles II's French background, it was inevitable that French fashions should come to dominate in England. Boots, with their Civil War associations, disappeared as fashion wear but were retained for riding. For English men, black and brown were the most common colours for footwear, but white was used for ceremonial and court wear.

The long square toe seems to have become particularly fashionable on Charles II's return from exile, although examples had appeared in the 1650s. The red sole and heel, a fashion of the French court, also became more common in England from this period.

Buckles and Bows

A portrait of Charles II by J.M. Wright (1661), in H.M. the Queen's Collection, shows him enthroned in his coronation robes. He wears white leather shoes with shallow square toe, high red heels and red sole, but notably a buckle fastening over a high tongue. This innovation had been noted a year earlier by Samuel Pepys in his *Diary* on 22 January 1660, in the much-quoted remark: 'This day I began to put on buckles to my shoes'. Although not widely adopted as a fashion immediately, buckles were to become a prominent feature of men's and women's shoes until the French Revolution (fig. 6b).

Plate 9 opposite Woman's silk mule with forked toe; English, 1660s–70s. Embroidered with raised work in silk and silver thread. T.860A-1974

The buckle was an adaptation of the latchet tie. Although essentially a method of fastening, buckles were always treated as separate items from the shoe itself, and as jewellery to be preserved and transferred from one pair of shoes to another. This has resulted in the survival of pairs of shoes without their buckles. The latter have generally also been preserved separately, and cannot usually be matched up with any particular pair of shoes.

The fashion for buckles seems to have come in at about the same time as the mode for absurdly wide ribbon bows, which Louis XIV's court favoured. In 1660, Louis XIV was presented with a pair of shoes with high red heels and bows 16 inches (40cms) in width, and several portraits of Louis' court in the 1660s show the court wearing shoes with huge bows. Sometimes both buckles and ribbons were worn on the same pair of shoes, thereby maximising their fashionable appeal. Multiple ribbons and ribbon ties were worn alongside buckles throughout Charles II's reign, but subsequently buckles predominated until the French Revolution. In the seventeenth century, buckles remained small and set off the decorative tops of high-tongued shoes, such as seen in fig. 6b.

Fig. 6a far left Engraving of French female négligé costume. After J.D. de St Jean, 1693. Depicts high heeled mules. 26363–10

Fig. 6b left Engraving of French male costume. After J.D. de St Jean, 1695. Depicts square-toed, high-heeled shoes with high tongue and small buckle. 26363–17

Femme de qualité en deshabillé negligé

Homme de qualité en habit de Teckeli

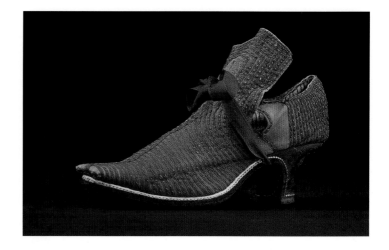

Women's Shoes: the Long Square Toe

The long squared-off toe was popular for women from the 1660s to the 1680s. A pair of women's shoes of this style in the V&A retains the latchet and ribbon tie fastening (plate 10). Buckles were in vogue for women as well as men but adopted less assiduously, probably because they rubbed against the hems of their dresses. The shoe shown here has a small side opening. Openings were diminishing in size by this time and are no longer the conspicuous fashion feature that they had been earlier in the century. In the eighteenth century they disappeared altogether.

For men's shoes, the side opening seems to have disappeared earlier, particularly for sturdy outdoor wear, as noted by Randle Holme (1688): 'Close shoes as such as have no open in the sides of the latchets, but are made close up like an Irish brogue. They are to travel with in foul and snowy weather'.

Overshoes: the Slapsole

Overshoes of various forms were in use in the seventeenth century, worn to protect flimsy shoes and boots. Clogs and pattens were the usual forms of protection, worn over shoes to keep the wearer's feet out of the mud. There were also flat-soled versions with just a toe-cap, known as goloshes, worn over both shoes and boots. A small number

of shoes survive which were made with the flat golosh sole attached. These were known colloquially as 'slapsoles': the heel on the golosh was not attached to the shoe, and this caused the undersole to slap up and down as the foot flexed in walking. Two slapsoles (not a pair) from the V&A's collection, the larger seen in plate 11, are particularly interesting as they are of very similar styles but different sizes. They may perhaps have been made for a special occasion for an adult and child or very young woman. In these two examples the heel is actually attached to the sole, which would have made walking considerably easier than in a 'true' slapsole. Other collections, including those at Northampton Museum and the Museum of London, have examples of slapsoles, and there are also versions in other European collections. It seems likely that they were not actually much worn and were a fashion extreme rather than of any genuine practical value.

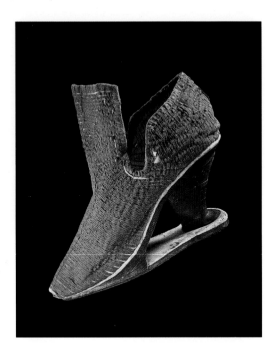

The Pointed Toe

Pointed shoes for women marked the first real divergence between shoe fashions for men and women, probably developing from the tapered square. For about the last quarter of the seventeenth century, the pointed toe was an entirely feminine fashion and the high heel (particularly pronounced on French shoes) which accompanied it assisted in the fashionable deception that women of quality had tiny feet. Towards the end of the seventeenth century the pointed toe on women's shoes became upturned, a fashion described by Randle Holme (1688), as 'hooked'.

Leather was commonly used for working women's shoes. To a lesser extent it was also used for women's fashionable outdoor wear, but was not as common as the more exotic materials such as velvet or silk. A rare surviving pair of fashionable women's leather shoes, of about 1700 (plate 12), shows the contemporary style of pointed, slightly upturned toe with white rand, red leather heel and latchet and ribbon fastening.

Plate 11 above Woman's kid 'slapsole' shoe with lines of silk ribbon decoration; Italian? 1670s. The stacked leather heel is attached to the golosh sole with a rounded piece of leather; slapsoles usually have unattached heels, from which the name derives. HH 519–1948; Ham House, Richmond, Surrey

Plate 12 opposite Leather woman's shoe with pointed toe; English, *c.*1700. White vellum rand, red leather heel and latchet, and ribbbon fastening. The ribbon is a modern addition. 1124–1901

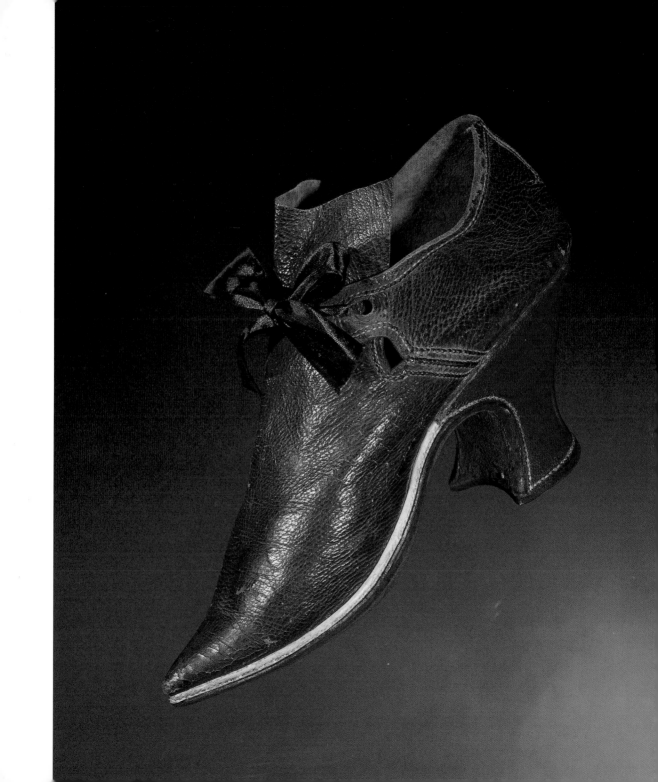

Chapter Three

Taste and Elegance: 1700–1750

The Cupula-coat allows all the freedom of motion; the graceful walk, the majestic step, not to mention the beauty and splendour of the foot which plays visibly within the circle and ravishes the eye of the watchful beholder. (*The Whitehall Evening Post,* 1747)

At the beginning of this period the gentry advertised its wealth and status through sumptuous clothes and accessories. As the century progressed, however, wealth generated by the growth of trade increased the prosperity of the middle classes. They were keen to imitate their superiors and one of the ways in which they sought to elevate their social status was through wearing fashionable dress and stylish shoes.

New forms of entertainment such as assemblies, as well as the development of pleasure gardens and spas, offered opportunities for members of respectable society to place themselves before the public gaze. The motions of walking, dancing and sitting down at such events or places might reveal a fine shoe beneath a flowing gown, or the sparkle of a buckle as it caught the light. The wide-hooped petticoats which came into fashion also provided an opportunity to show off the feet. Elegant footwear therefore became more prominent in the language of display.

The Fabric of Fashion

The Weekly Journal, of 1 May 1736, commented: 'The ladies shoes were exceeding rich, being either pink, white, or green silk, with gold or silver lace and braid all over, with low heels, and low hind-quarters, and low flaps, and an abundance had large diamond shoe-buckles'.

Throughout the first half of the eighteenth century, the colours and materials of fashionable women's shoes often reflected the elegance of their gowns. Fabrics ranged from delicate silks to sturdier materials,

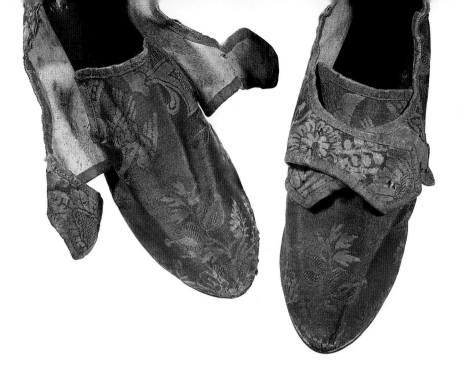

Fig. 7 above Detail of a pair of blue, ivory and green brocaded silk shoes; British or French, *c.*1740. The date is suggested by the low heel and rounded toe, although the silk is much earlier, dating from 1705–20. The shoes would have been fastened with a buckle.
T.443&A–1913

such as leather and wool, for everyday wear (see Frontispiece and plate 1). The uppers and soles would be cut out separately and then sold on to the shoemaker who adapted them to the shape of the last. This helps account for the asymmetrical positioning of the fabrics on many surviving shoes (fig. 7). They were usually lined with kid, silk or canvas, and the combination of fragile materials forming the upper called for a great deal of skill at the hands of the shoemaker:

It is much more ingenious to make a Woman's shoe than a Man's: Few are good at both, they are frequently two distinct Branches; the Woman's Shoe-Maker requires much neater Seams as the Materials are much finer. They employ Women to bind their shoes and sew the Quarters together, when they are made of Silk, Damask or Callimanco (R. Campbell, *The London Tradesman,* 1747).

It is, however, rare to find a shoe which exactly matches the damask and brocaded silk designs of the dress. It would have been too complicated and costly for most women to acquire matching shoes for every gown. Moreover, as shoes were usually viewed from some distance and glimpsed beneath the hem of a skirt, it would not have

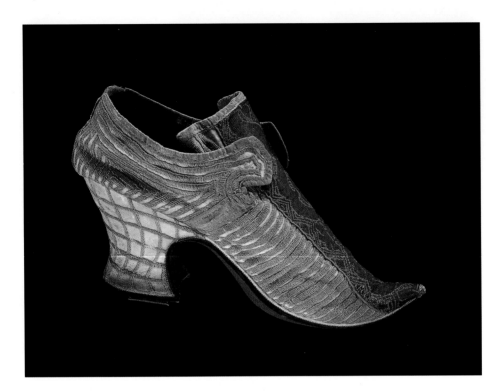

mattered if the pattern was slightly different. This might explain why the shoes in fig. 7 can be dated to the 1740s from their style but are covered in a much earlier silk. The woman who wore them probably had a dress of similar colours and asked the shoemaker to hide the outdated bird design under the latchets, leaving the floral decoration on the toe which would have blended in with a silk of this period.

Richly trimmed or embroidered shoes could, on the other hand, be used with a number of different garments. The criss-cross and parallel lines of applied decoration on the shoes in plate 13 resemble the designs on quilted petticoats which were worn with open-fronted gowns. Broad bands of silver-gilt braid decorating the front of the uppers became very popular in the 1730s and 1740s (see plate 13). They were known as 'laces' and could easily be added to or removed from the shoe to suit the costume or occasion. In a painting attributed to Thomas Gibson (fig. 8), Henrietta Howard, Countess of Suffolk,

Plate 13 above Woman's silk shoe; British, 1720s–30s. Decorated with silver-gilt braid and embroidery. Faint pencil markings delineating the parallel stripes and lattice design are still visible in places. The toe curves upwards, rather like the prow of a ship. 230–1908

wears 'laced' shoes to match the braid on her stomacher and skirts. When the heroine of Samuel Richardson's novel *Pamela* (1740–41) believes she is returning home from her position as a favoured maid, she removes the 'lace' from her shoes, with the intention of replacing it with plain buckles more suited to village life.

Heels, Toes and the Art of Movement

The shape of the stylish English lady's shoe, with its thick, waisted heel and prow-shaped toe, varied very little during the early eighteenth century (plate 13). Although they look more sturdy than some of the slender tapering styles then fashionable in France, they cannot have been particularly easy to walk in. If the heel was placed too far under the instep, or sloped at an abrupt angle, the foot was likely to fall backwards (plate 14). Moreover, the higher the heel, the more the weight of the body would be thrust forward onto the balls of the feet, causing considerable strain. Despite such impracticalities, women were expected to walk smoothly and it is little wonder that carriage and posture became such an art. Dancing masters taught the virtues of graceful movement, and children practised walking in shoes, hoops and wigs from an early age.

By the 1740s a greater variety of styles, including blunter toes and broader, lower heels, were coming into fashion, but this does not mean that shoes were necessarily more comfortable. They were still made as 'straights' which forced the toes into unnatural directions and caused distortions, despite the common practice of frequently changing the shoes from one foot to the other. The flatter, more shallow shapes also offered little protection against the hazards of stony ground and unpaved streets. Dr Camper, writing in the 1770s, argued that shoes curved up like the front of skate irons (see plate 13) at least prevented the wearer from bruising her feet on loose stones and cobbles.

An elegant ankle was much admired in a man. Although his black or brown leather shoes tended to be more practical than women's footwear, the dark tones would have set off

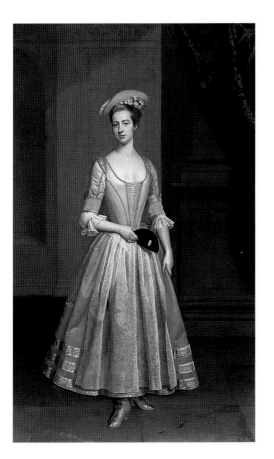

Fig. 8 below Painting of Henrietta Howard, Countess of Suffolk. Attributed to Thomas Gibson (early 18th century). Blickling Hall, Norfolk. National Trust Photographic Library/John Hammond

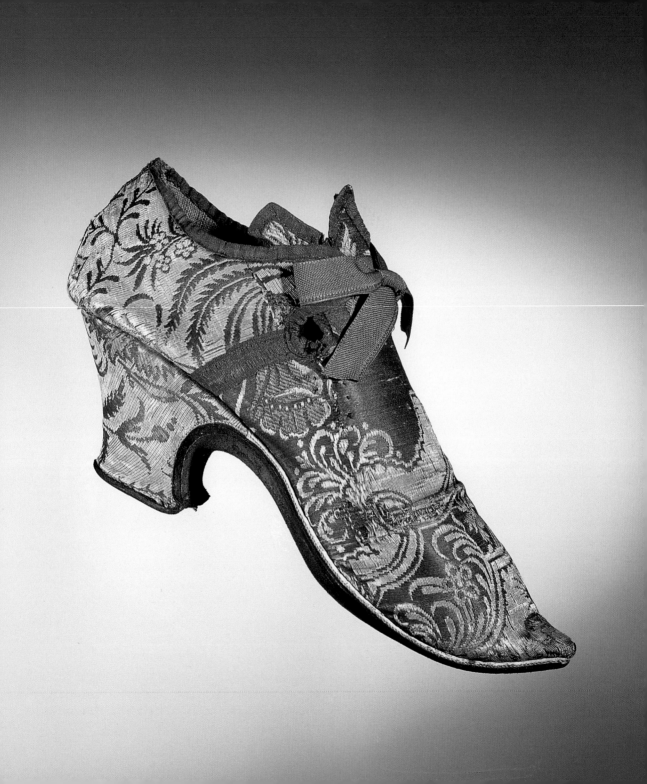

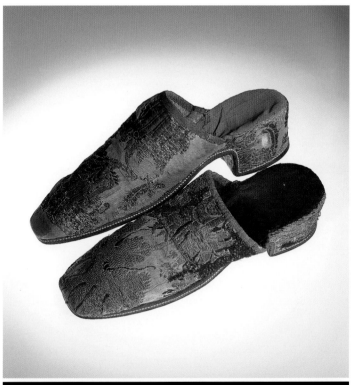

Plate 14 left Ribbon-tied woman's shoe with vandyked tongue; English, *c*.1720. Covered in Spitalfields brocaded silk dating from 1715–20. The sloping heel and the pressure of the foot has caused the back of the upper to extend over the sole. The ribbon tie is not original. T.446–1913.

Plate 15 above Man's mule slippers (not a pair) of silk brocaded with metal thread; British, 1710–20s. T.8–1922; T.9–1922

Plate 16 right Man's dress shoe with rounded toe and long latchets for a buckle; British, 1740s–50s. The low, stacked heel appears to have been originally coloured blue. T.151–1937

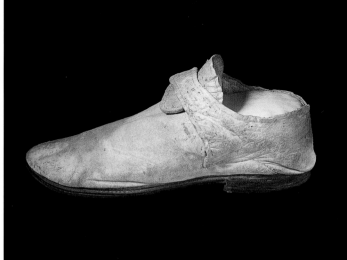

the glistening buckles and pale stockings with which they were often worn. Lighter and brighter colours were reserved for court, special occasions and extravagant dressing (plate 16). The Prince of Wales donned a pair of 'white shoes' for his wedding day in May 1736 and *Mist's Journal* of 1727 describes a young dandy of the day sporting red heels about town. The squared blocked toe, fashionable during the reign of George I (1714–27), had virtually died out by the end of the 1720s. It was replaced by a rounder shape and the term 'old square toes' came to be used in mockery against the older generation. The whole style of a man's shoe gradually became less heavy and heels dropped to about an inch (2.5cms) in height, as in plate 16.

Throughout the eighteenth century a gentleman was often most at ease in his nightgown and 'slippers' (plate 15). He wore them to relax privately in his home, receive visitors and sometimes even as a sign of informality out-of-doors. Cut in the form of a mule, they often matched the rich materials of the nightgown, as described in an early eighteenth-century advertisement: 'Taken from a Gentleman's House ...A flour'd Saten Night gown, lin'd with Pink colour'd Lustring, and a Cap and Slippers of the Same' (quoted by John Ashton in *Social Life in the Reign of Queen Anne*).

Boots: for Jockeys or Gentlemen?

Boots were largely reserved for riding, hunting, travelling and military use. Pehr Kalm, a Swedish botanist who visited England in 1748, noted how anyone walking in town wearing boots would always carry a riding whip as a sign that he had ridden in. A growing interest in horse-racing, however, led to the rise of the jockey boot (see plate 35a) as an item of fashionable clothing. By the 1730s they were becoming an increasingly familiar sight. Ending just below the knee, they had a turned-down top of a softer or lighter coloured leather and were pulled on using leather or string loops. Although dashing to the eye, such styles were not always approved of, particularly indoors. The popular press loved to poke fun at the young sparks who wore boots, likening them to 'jockeys', 'footmen', 'grooms' and even 'pickpockets' as they strutted about the streets or congregated in boxes at the theatre.

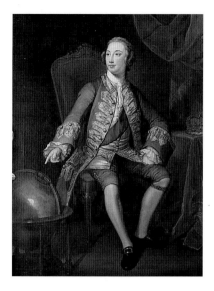

Buckles and Ribbons

Gold or silver buckles often gave the finishing touch to a shapely foot (fig. 9). They fastened the latchets of the shoes over the tongues and were one of the few pieces of jewellery worn by men. Making beautiful buckles became a highly skilled craft at which the English silversmith and jeweller excelled. Exquisitely carved designs, glittering pastes and precious stones reflected the status of the wearer as well as the occasion. Cheaper and plainer versions were made of steel, brass and pinchbeck. A gentleman often possessed several pairs of buckles which he could transfer between shoes to suit his needs. He might also wear matching knee buckles to fasten his breeches at the sides, as in fig. 9.

Although many women wore small square or oblong buckles, some still preferred to fasten their shoes with ribbon ties (see plate 14). This was probably a practical consideration. Hooped petticoats helped raise the skirts above the ground but the prongs and sharp edges of a buckle might easily become ensnared in the flowing lengths of a gown. Men had to be cautious too, and the various hazards which might befall them are well illustrated in a poem by Soame Jenyns:

Thin be his yielding sole and low his heel,
Nor need I, sure, bid prudent youths beware
Lest with erected tongues their buckles stare,
The pointed steel shall oft their stockings rend
And oft th' approaching petticoat offend.
(*The Art of Dancing,* 1730)

This satirical note might also have had something to do with the size of men's buckles, which reached enormous proportions after 1730. Some were so large that they covered a man's instep and half of his foot.

Sole Protectors

Pattens (plate 17) were often worn to lift the shoe out of the dirt and damp. Despite their beneficial qualities, the wooden sole and iron ring must have made them very heavy and uncomfortable. Gentlewomen sometimes found occasion to use them, but because of their functional appearance they were more generally associated with

Fig. 9 above Portrait of the Prince of Wales; later George III (r.1760–1820). British, *c.*1750. He is wearing large silver buckles on his shoes and his breeches are fastened at the side with a matching knee buckle. W.35–1972

the lower classes and country people. In his poem *Trivia* of 1712, John Gay wrote of working housewives 'clinking' through the wet London streets on pattens and Pehr Kalm noted how women of farming families '...wear their *pattens* under their ordinary shoes when they go out to prevent the dirt on the roads and streets from soiling their ordinary shoes' *(Kalm's Account of his Visit to England,* 1748).

Leather overshoes, known as 'clogs', were the elegant alternative to pattens (plate 18). They were often covered in fine materials or decorative leather stitching, to complement the richness of the shoe. Curved and shaped to fit neatly under the arch, they would have supported the foot, perhaps making the high heels easier to walk in. But the thin leather soles of the clogs offered little protection from the dirt of the roads or unpaved streets. The lack of wear on the soles of surviving pairs suggests that they were worn in dry conditions; inside the house, hackney carriage or sedan chair. Clogs are therefore generally linked to luxurious lifestyles or to those who wished to imitate the fashions of their betters. In 1725 Daniel Defoe published *Every-Body's Business, is No-Body's Business,* a pamphlet on the social embarrassment caused by well-dressed serving maids. To highlight the problem he described how a country girl, aspiring to dress like her mistress, kicked away her 'high wooden pattens' for 'leather clogs' when she became a London maidservant.

Plate 17 left Patten with wooden sole and iron ring; British, 1720s–30s. The heel socket and latchet fastenings would have helped secure the patten to the woman's shoe. It is likely that this example was worn by someone of genteel birth as the latchets are covered in velvet, an expensive material. T.43–1922

Plate 18 opposite Woman's shoe of brocaded Spitalfields silk with latchets for a buckle; British, late 1730s to early 1740s. The leather clog is partly covered in velvet and the sole is similar in shape to the base of a chopine. T.274A&C–1922

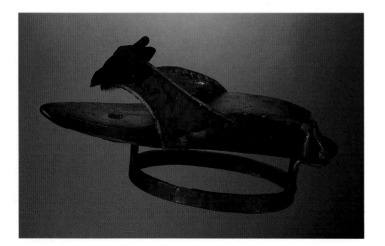

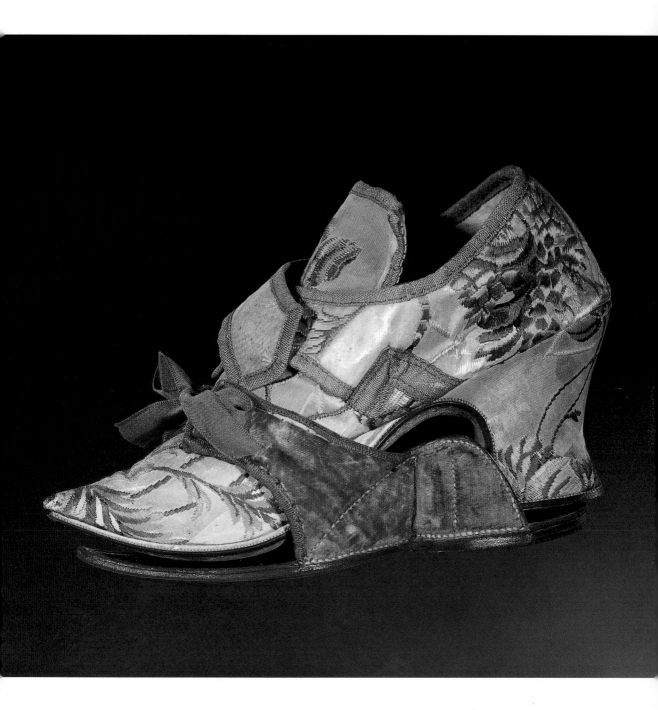

Chapter Four

The Revolutionary Shoe: 1750–1795

In England, Fashion, it is true, shifts like the weather cock, with every breeze; but in France, it keeps one continual whirl like the fliers of a jack.
(*The Fashionable Magazine,* August 1786)

The growth of prosperity during this era produced a wider market than ever before for luxury goods, including fine clothes and shoes. The fashion-conscious kept up with the latest styles through observation, letters, and by means of the popular press. From the beginning of the century journals had carried descriptions of new styles of dress, but frequently with a satirical or moralising edge. The 1750s saw the beginnings of illustrated descriptions of fashion which had no other intent but to inspire and inform.

During the third quarter of the eighteenth century French and Italian shoe styles quite literally reached their height. High and brittle heels made some shoes positively unstable while buckles grew in size and extravagance. From the 1780s, however, a taste for simplicity began to prevail in Britain, a movement given further impetus by the reaction to social and political events in France. More practical styles of footwear, such as boots, became increasingly popular, as if to meet an increasingly energetic society's need for less formal costume.

'Tott'ring every step they go': Women's Shoes 1750–65
Despite Anglo-French hostilities, the British often looked to Paris as a source of inspiration. Rococo styles were never adopted in Britain with the same enthusiasm as they were in France, but they did make some impact, particularly during the 1750s and 1760s. Many lamented the 'frivolous', 'ridiculous' and sometimes 'indecent' fashions which they claimed were corrupting English dress. Such criticisms do not

Plate 19 opposite Buckle-fastened woman's shoe; British or French, 1750s–60s. The 'French' or 'Pompadour' heel measures 4 inches (10.5cm) in height and is covered in silk damask. The upper is covered in brocaded silk woven in Lyons dating from the 1730s. T.423A–1913

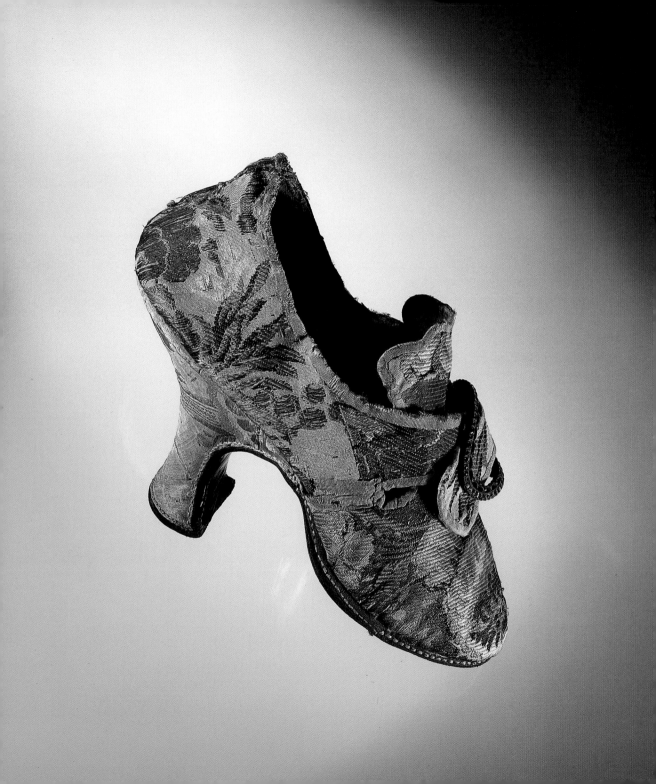

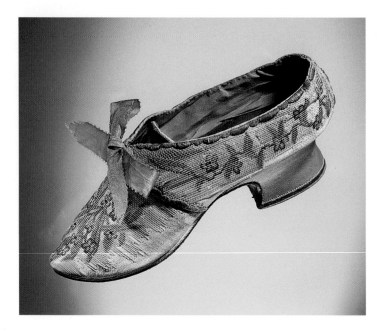

Plate 20 left Woman's shoe; French, German or Italian, 1750s. Decorated with couched straw 'splints', flowers and leaves embroidered in silk, and scalloped edges of silver-gilt thread. The latchets are tied over the low tongue with silk ribbon and the broad heel is covered in satin. T.69A–1947

Plate 21 opposite Pair of woman's shoes with floral designs painted onto kid; Brussels, 1760s. The curving heel is covered in silk satin and the latchets would have been fastened with a buckle over the tongue. 270&A–1891

Fig. 10 below Detail of a lappet in Flemish (Brussels) bobbin lace; Brussels, 1740s–50s. T.316–1971

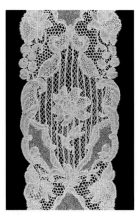

seem to have prevented women from adopting the precariously high and sensuously curving 'French' or 'Pompadour' heels (plate 19). Named after Madame de Pompadour, an official mistress of Louis XV, they were narrow-waisted with a very small, tilted base. A heel of such dramatic height, positioned directly under the instep, would have made the foot look petite – but beauty had its price. Perhaps the poet Francis Fawkes was exaggerating when he described women 'tott'ring' on these heels (*His Mistress's Picture,* 1755), but they may well have hindered the wearer from walking firmly in an attempt to alleviate the agony suffered by her toes.

Not all heels would have been so uncomfortable, and a huge variety of shapes continued to prevail, 'some as broad as a tea-cup's brim, some as narrow as the china circle the cup stands upon' (*The London Chronicle,* 1762). Although shoes of brocaded silk and wool remained popular, more unusual materials were occasionally used, such as ornate straw-work (plate 20) and richly decorated leather. In 1767 Lady Mary Coke bought six pairs of painted leather shoes from a shop in Brussels. Those in plate 21 are possibly very similar, as the design

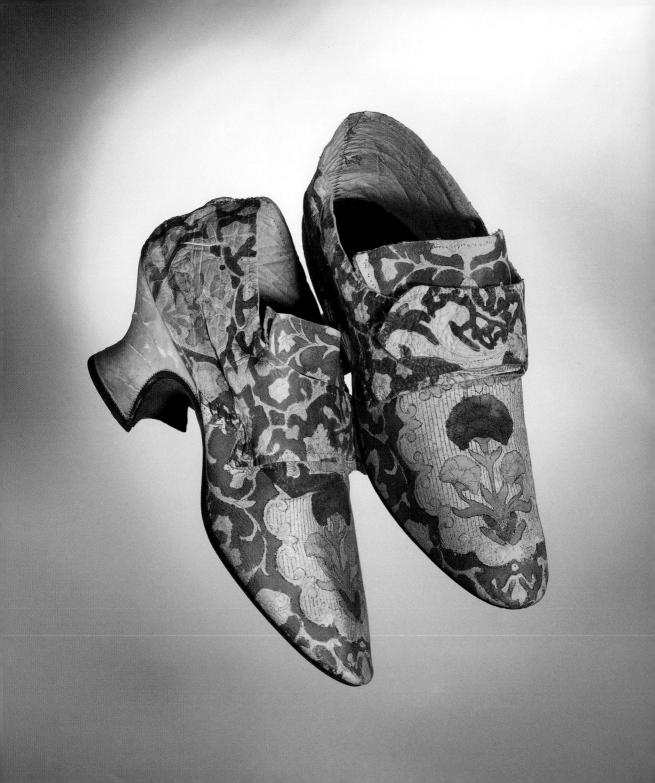

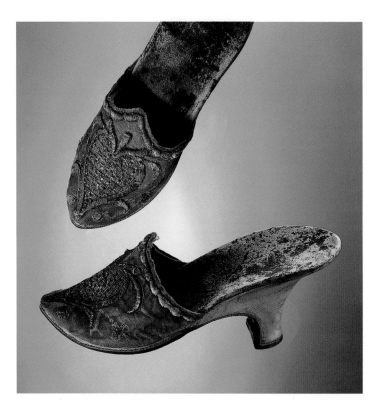

on the toe, with its vertical lines, scalloped edges and flowering plant closely resembles the patterns on the Brussels lace lappet in fig. 10.

High-heeled mules, commonly known as 'slippers', became increasingly popular for indoor wear (plate 22). In 1772, a commentator in *The London Magazine* marvelled at how well women danced and how firmly they walked in this type of shoe. The name 'slipper' also applied to a type of 'slip-on' shoe without fastenings (see fig. 11). Often very fragile and finely decorated, they were best set off by an elegant ankle. In *The Life and Adventures of Sir Launcelot Greaves* (by T. Smollett, 1762), Sir Launcelot holds forth against the pretensions of rich yeomen whose families ill-advisedly followed this fashion: '...their wives and daughters appeared in their jewels, their silks and their satins, their negligees and trollopees; their clumsy shanks like so many shins of beef, new cased in silk hose and embroidered slippers'.

The Influence of Italy: 1760s–80s

By the middle of the century, increasing numbers of wealthy and influential Englishmen were undertaking the Grand Tour of the continent. Young men who had travelled in Italy introduced the term 'Macaroni' to signify anything particularly stylish and elegant. The word also came to be linked with fops, who dressed extravagantly in tight-fitting clothes and low-cut shoes weighed down by enormous buckles.

The Italian influence on women's dress, however, was rather more subtle. The slender 'Italian' heel with its wedge-like extension under the instep (plate 23) gained in favour during the late 1760s. Made of wood and usually covered in a white or cream material to contrast with the colour of the upper, they were extremely elegant. The toes were often embroidered in silver-gilt threads, spangles or foils, and *The Fashionable Magazine* of 1786 included 'fancy patterns' for shoe vamps very similar to those in plate 23. The delicate form of the shoe would have accentuated the shapeliness of the leg, complementing the shorter styles of dress which were popular in the 1770s and 1780s (see plate 24).

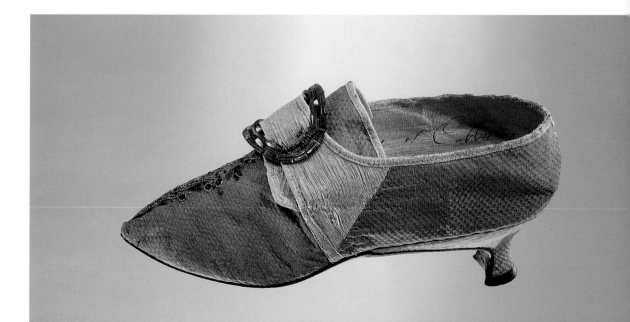

Although stylish, they were highly unstable. Heels became so thin and high that they required the reinforcement of a metal spike down the middle to prevent them from snapping. This would have made them impractical for walking on cobbles, and it seems hardly surprising that their emergence coincided with the more widespread paving of streets. There were of course other styles to choose from but, according to Dr Camper, all were equally injurious to the foot:

...from our earliest infancy, shoes, as at present worn, serve but to deform the toes and cover the feet with corns, which not only render walking painful, but, in some cases, absolutely impossible...We bestow reasonable compassion upon the fate of the Chinese women, who dislocate their feet in obedience to the dictates of a barbarous custom, and yet we ourselves have submitted complacently for ages to tortures no less cruel (*The Best Form of Shoe, c.*1770).

Fig. 11 left Silk satin woman's 'slipper' with pointed tongue and high, slender heel; French or Italian, 1770s–80s. This shoe is very similar in style to those worn by the woman in plate 24. T.215-1916

Plate 24 opposite JACK OAKHAM *throwing out A SIGNAL for an ENGAGEMENT.* Hand-coloured print, British (London), May 1781. Private collection. Reproduced by kind permission of Mrs Pamela Pratt.

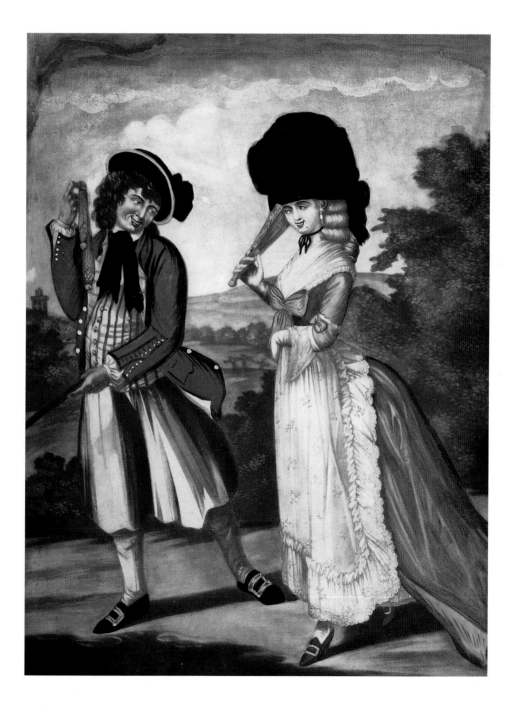

Buckles: an Extravagance

Shoe buckles for both men and women grew in size and extravagance. They reached their extreme in the enormous Artois style of 1777. Some were so large that the latchets wore out very quickly and had to be replaced. Buckles displaying sparkling pastes set in exquisite patterns (fig. 12), Wedgwood cameos and silver-gilt embroidery all created dazzling effects. One writer was so struck by the appearance of her lover that she recorded in *The Lady's Magazine* of 1784: 'His buckles totally covered his shoes and almost blinded me with their brilliancy'.

Even the lower classes kept up with the fashion for larger buckles. Although they were often made of cheaper materials, as wealth increased and new manufacturing processes boosted supply such luxuries were affordable to more and more people. *The Gentleman's Magazine* of June 1777 observed: 'All our young fops of quality, and even the lowest of our people in London, wear coach-harness buckles, the latter in brass, white metal and pinchbeck'.

The Natural Form

By the mid-1780s, more natural styles had become fashionable in English dress. Many women adopted a simpler style of shoe to accompany their flowing gowns of silk gauze or fine muslin. Often made of plain leather, with medium-sized heels and pointed toes, they were meant to make the foot look graceful. *The Lady's Magazine* of May 1785 remarked that whereas high heels were dangerous and low ones unflattering, 'a heel about an inch and a half high, will make the wearer tread firmly, and will not deform the leg'. Although some shoes were still fastened with buckles, slippers (similar to those in fig. 11) became increasingly fashionable. This was probably because they were simpler in style and less likely to become entangled in the longer gowns.

Many men also preferred to replace the buckle with ribbon ties. Until then shoe-strings had been disliked in genteel society, perhaps because of their associations with the labouring classes. Their re-emergence is probably linked to the general move towards more informal and comfortable styles of dress. During the second half of

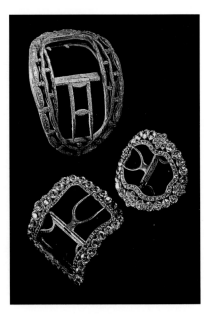

Fig. 12 below Men's and women's buckles. Top (a): Man's buckle with silver decoration mounted onto iron; British, 1780s. The chape is inscribed with the maker's name: 'Bingham'. T.357:1–1998
Bottom left (b): Square silver buckle, man's?, inset with paste stones; British, c.1780. 945A–1864
Bottom right (c): Round silver buckle, woman's, inset with paste stones. British, c.1780. 974A–1864

the century men's shoes became lower cut, a fashion which shifted the buckle nearer the toe (see plate 24). A large and heavy buckle would weigh down the front of the foot causing the heel to slip up over the back of the shoe when walking. A ribbon tie which lightly but firmly secured the shoe to the instep was far better suited to an active life of work or pleasure. They were also worn by London fops with some of the more extravagant fashions of the day, as a satirical poem in the June 1786 issue of *The Fashionable Magazine* suggests:

The Men, precious creatures, in high and stiff capes,
Strut with all the erectness of newly-train'd apes;
While ribbands, which might for their necks form a noose,
Are idly transferr'd to tie only their shoes.

Sporting Styles

The English gentleman so devoted himself to country pursuits that he wore sporting dress for much of the day. Boots became more and more popular in town as well as on the country estate, although their presence was still not always welcome inside the house. Fanny Burney's heroine, Evelina, is certainly dismayed by the appearance of the brash Lord Merton, who 'came shuffling into the room with his boots on, and his whip in his hand' (*Evelina*, 1778).

By the 1780s, however, the fashion for boots was so widespread that foreigners identified them as a characteristic of British dress. Young French dandies took to wearing them, much to the dismay of critics like Louis-Sébastian Mercier who expressed his disapproval of the prevailing vogue for Anglomania in his *Tableau de Paris* (1782–88), bemoaning the 'ton parmi la jeunesse de copier l'Anglois dans son habillement (fashion among the young to copy English dress)'. The most popular style was still the jockey boot (plate 35a), re-named the top boot, possibly to dispel any associations with the working classes. Some were so close fitting that they were difficult to remove without assistance.

Women also began wearing fashionable clothes inspired by country styles. During the 1780s the riding coat as well as the boot became fashionable for walking costume, and the impropriety of women

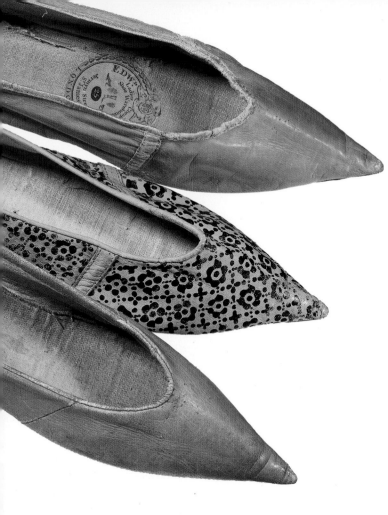

Plate 25 left Women's shoes. Bottom (a): Detail of a leather shoe with a pointed toe and U-shaped throat; British, 1790s. 151–1900 Middle (b): Detail of a leather shoe with stencilled decoration; British, *c*.1800. T.10–1918 Top (c): Detail of a leather shoe; British, 1790s. The label on the insole reads 'EDWD. HOGG. Ladies Cheap Shoe Warehouse. 25 Jermyn Street. St. James's, LONDON'. T.481–1913

(who never rode) strutting about the streets in half-boots, great coats and neckcloths excited much comment, particularly as they looked so masculine. Even pattens (plate 17) gained a certain fashionable status in the spa town of Bath where, according to Betsy Sheridan's *Journal* of 1789, 'We Ladies here trot about in Pattens, a privilege granted no where else to genteel Women'.

The Revolutionary Shoe

Reactions to the French Revolution strongly influenced developments in English dress. Shoe styles were gradually becoming simpler during the 1780s, but events in France acted as a catalyst, speeding up the

processes of change. Conspicuous symbols of wealth, such as extravagant shoe buckles, were not in keeping with the ideals of liberty, equality and democracy advocated by the newly elected French National Assembly. The authorities in Paris encouraged donations of buckles to the *caisse patriotique,* established during the autumn of 1789. Enthusiasm for French fashions, as well as a degree of sympathy with the early stages of the Revolution, also hastened the decline of the shoe buckle in Britain. Of course they did not disappear overnight, and heavy clumsier versions continued to be worn for court and evening dress well into the next century. But decreased demand in Britain, combined with the loss of the once flourishing export trade to France, meant that by 1791 there were large numbers of bucklemakers out of work in the Birmingham area. According to the Dutch fashion magazine, *Kabinet van Mode en Smaak,* in April 1792:

English fashions can hardly be seen; everything is in the French taste, which gains more ground, because of the general desire of the Ladies to visit France...Despite all the petitions of the Birmingham manufacturers to the Queen, the Princesses and the Prince of Wales, shoe buckles refuse to come into fashion again.

Many women's shoes (also known as slippers) followed the French fashion for broad, flat heels, a low V or U shaped throat and long pointed toes (plate 25). In the early 1790s 'sandle shoes', which were tied on with criss-cross ribbons, also became fashionable (a later example is shown in fig. 13a). These were inspired by the French *cothurnes* or *sandales* which formed part of a distinctive style of 'revolutionary' dress, modelled on the clothes of classical antiquity. Nancy Woodforde, a country parson's niece, acquired a black and yellow pair in 1792, but she probably chose them for their charm rather than their associations with the Revolution, which was rapidly moving towards a bloody climax.

The 'Terror' of 1793–94 and the downfall of the monarchy reawakened latent hostility towards French dress and manners. The Parisian fashion magazines fell silent, and the few depictions of clothing which did emerge were largely in the form of caricatures. During these years dress in Britain and France developed along quite different lines.

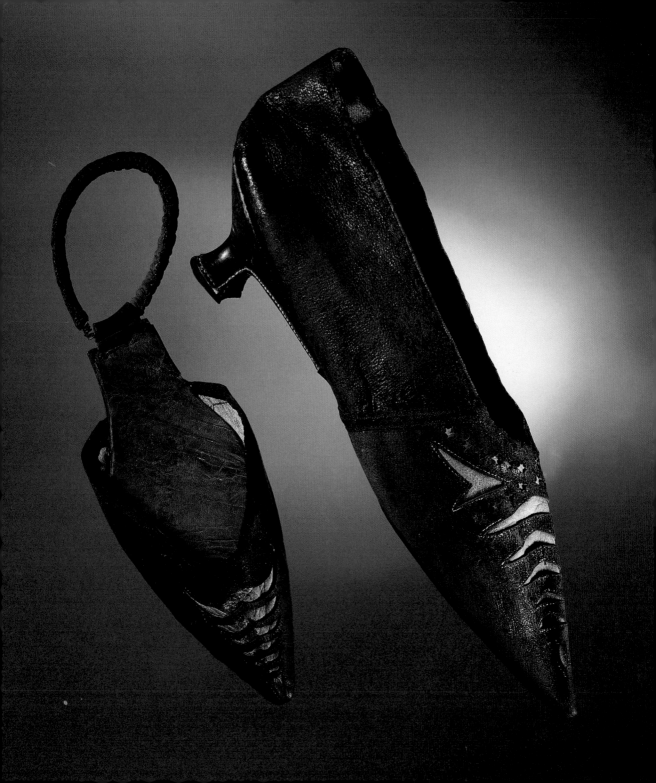

Chapter Five

Classicism and Romanticism:

1795 to the mid–1830s

The model of fashions which used to be dispatched every week from Paris, to reign without controul [sic] in all the toilettes in Europe, is no longer sent abroad to give the law in dress...To that well-conducted legislation, which formerly regulated with so much propriety the colour of a ribband, the size of the shoe, the thickness of the waist, the most complete anarchy has succeeded. (*The Lady's Magazine,* March 1797)

By the mid-1790s significant differences had emerged between French and British shoe styles. The latest Parisian modes could not, however, be ignored for long and the re-establishment of communications after the end of the Terror revealed the classical tastes of the new Republic. A simpler style of dress developed that extended to footwear; indeed some shoes were so basic they could be produced at home. Even the continuous wars with the French had an effect, as boots with military associations became popular and trimmings derived from army uniforms appeared on footwear. Although practical and utilitarian styles flourished during the Napoleonic period, the Romantic movement of the 1820s and 1830s inspired greater exuberance in the dress of both sexes. Subtle changes in footwear, such as squared toes and new colours, reflected these developments.

The Classical Line and Gothic Ornament: 1795–1815

The disruption of links with France during the mid-1790s had a considerable impact on women's costume in Britain. Whereas French dress favoured a pure, classical style, the British tended to combine neoclassical influences with lavish romantic ornament. Such variations are reflected in many shoes of this period. Although the 'slipper' retained its low-cut shape (plate 26) and 'sandle shoes' (fig. 13a),

Plate 26 opposite Woman's shoe of cut and punched leather with pale kid underlay; British, 1797. The overshoe is of a similar design and has a spring loop which would have fitted around the 'small Italian' heel (see the heel in plate 23 which is almost identical in shape). Shoe: 1126–1901; overshoe: 608C–1884

loosely based on Greek or Roman styles, remained popular, their decorative features were often very 'unclassical'. Cut-out patterns with coloured underlays reminiscent of the slashed designs on Tudor shoes became fashionable, and some slippers had matching toe-pieces to protect them out-of-doors (as can be seen in plate 26). There was also a short phase of higher heels, and in June 1797 *The Lady's Magazine* announced that 'Small Italian heels are again coming in with the rising generation' (plate 26 and fig. 13a).

By the end of the 1790s, however, Parisian styles were again exerting their influence on British taste. Once the Terror had ended and a reasonably secure government was established, French fashion magazines began to reappear. Descriptions of the latest classical styles were much admired, and the silhouette of British gowns gradually narrowed, becoming simpler with greater unity of design. Shoes were kept deliberately plain to preserve the pure lines of this fashion. Some were decorated with small bows or delicate patterns, but these generally harmonised with the details on the dress to create an elegant and uncluttered effect (see plate 25b and fig. 13b). Colours ranging from olive and lilac to orange often matched those on the pelisse, sash, hat, gloves or border of the pale muslin gowns, as described in *The Lady's Magazine* of 1799: 'Grecian dress; Round gown white muslin...fastened round the waist with a yellow girdle, having a border of purple flowers embroidered on it... Head-dress...with fillets of lilac and yellow. Lilac shoes'.

During the early years of the nineteenth century, classical influences remained strong (plate 27a). Fashion magazines, on both sides of the channel, frequently referred to Grecian slippers or Roman sandals, and some shoes were simple enough for women to make their own. The Honourable Mrs Calvert, for example, recorded in her *Souvenirs* (1808) how she had spent two hours with 'a master'

Fig. 13a below left Fashion plate showing walking dresses of 1797. Hand-coloured engraving; French, 1797. The woman on the right is wearing 'sandle' shoes: low-cut slippers fastened with ribbons which cross around the ankle and lower leg. Both women are wearing shoes with small, possibly 'Italian' heels. 298734.4

Fig. 13b below Fashion plate depicting a classical-style gown with yellow shoes stencilled in black; British, 1801. Hand-coloured engraving and stipple engraving, by H. Mutlow, from *The Lady's Magazine*. See plate 25b for a similar shoe. E.2044–1888

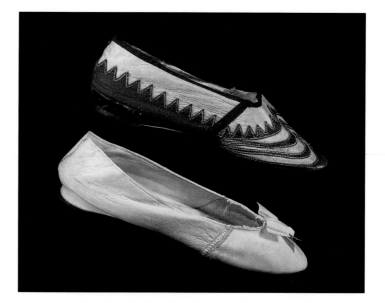

Plate 27 right Women's slippers. Bottom (a): Leather with a silk bow and low, wedge-shaped heel; British, 1810. This shoe is typical of the simple, yet elegant styles which were prevalent during the early nineteenth century. It was worn by a Mrs Grawshaw on her wedding day, 7 February 1810. The inner lining is inscribed with her maiden name, Miss E. Brown.
T.193–1914
Top (b): Leather, ornamented with vandyked and scalloped leather trimmings; British, *c.*1812. Although the basic shape is the same as in (a), the ornate decoration and the square throat cut higher on the instep show how shoe styles were changing.
T.479–1913

learning the 'Science' of shoe-making, and expected 'to make very nice shoes' herself. By 1812, however, a taste for greater ornamentation had again begun to interrupt the purity of the neoclassical line. So-called 'Gothic' styles inspired by Medieval, Tudor, Elizabethan and Stuart costume flourished in English dress, and ornate decoration adorned many shoes. Square-throated slippers were slashed across the front in a second brief revival of Tudor styles, and cutwork trimmings echoed the vandyked edgings on early seventeenth-century dress, as in plate 27b.

Masculine and Military Styles: 1795–1835

The long-toed man's shoe received much comment in the popular journals of the late 1790s. In October 1799, *The Lady's Magazine* commented: 'If ever, in some centuries to come, the little hat, stuffed coat, and long-toed shoe of a modern fine gentleman should be discovered in some museum of antiquities, or to survive upon the stage, they would no doubt give birth to many learned doubts and extraordinary *speculations*'. Although low-cut, bluntly pointed slippers were fashionable in the 1780s, they had never reached such extreme

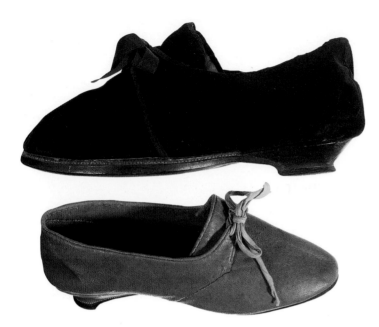

Plate 28 left Top (a): Man's shoe with velvet upper, rounded toe and wedge-shaped heel covered in leather; British, 1805–10. The ribbon tie (not original) fastens high over the instep. T.440–1988
Bottom (b): Woman's leather shoe, probably worn with walking dress; British, 1806–11. The round toe, wedge-shaped heel and latchets tied well over the instep are almost identical to those in (a). AP.1–1912

Fig. 14 below Bottom (a): Lace-tied woman's leather shoe with a raised sole; British, 1805–20. The laces are not original. Circ. 818–1920
Top (b): 'Promenade' or 'Carriage clog' with a raised cork sole and square toe; British, c.1825–35. The leather straps and toe cap would have fitted over the woman's shoe or boot, helping to protect the fragile silks and kid leathers of the upper from dirt and damp. T.460–1920

proportions. Fops were caricatured in their beribboned shoes, and the 'peaked' toe was compared to the fourteenth-century poulaine.

At the same time, however, more practical and comfortable shapes continued to gain in favour. By the beginning of the nineteenth century many men had adopted the higher-tongued shoe with rounded toes and latchets tied well over the instep (plate 28a). Women also began wearing similar styles (plates 28b and 31) and in January 1808 *The Lady's Monthly Museum* noted that black velvet lace-tied shoes were 'the newest Mode' in walking dress. Some designs combined shoe and patten in one (fig. 14a), raising the foot off the ground, yet passing as sufficiently elegant to be considered genteel. Although they remained popular for men, such styles were not to the taste of every lady. James Devlin, in his publication *The Shoemaker* (1840), describes how the 'woman's tie shoe' went out of fashion because of 'the tying being a trouble' and 'the shoe looking too masculine for the chaster taste of the wearer'.

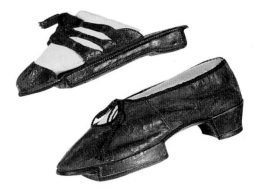

Fig. 15 above Parisian fashion plate showing fashionable men's dress of 1827. Hand-coloured engraving; French, 1827. The figure on the right is wearing Hessian boots with shallow, square toes.

E.1159–1974

During the period of the Napoleonic wars the army became more socially visible, and military costume influenced fashionable dress. The Hessian boot (fig. 15), originally associated with the light cavalry, was popular from 1795 until about 1830. Reaching to just below the knee, Hessians were cut with a peak at the front which was decorated by a tassel. Worn with pantaloons, they brought the glamour of military uniform into civil life. As an anonymous cavalry officer wrote in *The Whole Art of Dress* (1830): 'it is impossible to dress a fine leg, more especially of a short person, to greater advantage than in a Hessian'.

Wellington (plate 35b) and Blucher boots, named after the allied commanders at Waterloo, also appeared at this time. The former was similar to the top boot but without the turn-over top, while the Blucher was a half-boot laced over the tongue. Lacking adornment, both could be worn under trousers or pantaloons without spoiling their line. Some styles of Wellington had 'stockings' attached and were used as a substitute for dress shoes (plate 35b). *The Whole Art of Dress* explains: 'This boot is invented, doubtless, for the mere purpose of saving trouble in dress; for without attending to silk stockings or the trouble of tying *bows,* you have merely to slip on the boots, and you are *featly* equipped in a moment'.

Boots also became increasingly acceptable for women. By 1804, half-boots with front lacing and ribbon trimmings (plate 29) had started to appear in fashion illustrations for 'walking' or 'morning' dress. Many were still made of leather, although hardwearing alternatives were also available due to the huge increase in raw cotton imports towards the end of the eighteenth century and new processes of mechanization in the textile industry. Cotton jean became particularly popular (seen in plate 29b): *The Ladies Monthly Museum* of July 1812 remarked that 'jean demi-bottes' along with other items of dress would 'suit the parade as well as the picture gallery – equally cool for both purposes'. Although women's boots tended to be more delicate than men's, they were also adorned with decorations borrowed from military uniforms. In 1815 Elizabeth Grant described, in her *Memoirs of a Highland Lady* (1797–1827), how she had walked out in Edinburgh, 'like a hussar in a dark cloth pelisse trimmed with fur and braided like the coat of a staff-officer, boots to match, and a fur cap set on one side'.

Romanticism: 1825–1835

The Romantic movement inspired some of the most flamboyant styles of the nineteenth century. By 1830 puffed sleeves, tiny waists and bell-shaped skirts had reached such exaggerated proportions that women were compared to 'ants' and 'bottle spiders' (see plate 30). Shoes did not alter quite so dramatically, but the more compressed line of the dress extended to the shape of the toe, which became square after 1825. Heels also disappeared, perhaps to compensate for the increasing height of head wear and hairstyles. As skirts increased in width they also became shorter, focusing attention once again on the foot and ankle. Brightly coloured silk boots or slippers complemented the richness of the gown, sometimes matching the sash or long fluttering ribbons worn with the hat (see back jacket; plate 29a; plate 30). A wide range of colours was available with evocative names such as 'canary yellow', 'palm-leaf green', 'marshmallow blossom' and walnut-tree brown'. Even the black satin shoes which became increasingly popular for evening dress were not always left unadorned:

Some of our fashionables have made exchange in the slipper, lacing it up the front with coloured ribbons. Black satin shoes made in this manner, and laced with green or rose-colour, are very becoming to the foot; the rosettes are worn larger than they were, and ornaments in various styles will be probably introduced for dress shoes (*The World of Fashion*, October 1834).

Due to their fragility, silk slippers were probably reserved for indoor wear, evening dress or special occasions (see back jacket image). Kid shoes and boots tended to be more economical as they lasted longer, but they were also often very thin (plate 29c). 'Promenade clogs' and 'carriage clogs' therefore became an essential accessory for fashionable women wishing to keep their feet relatively dry and dirt-free (see fig. 14b). According to an 1830 trade advertisement of W. Jackman of Oxford Street, London, some were 'peculiar for their lightness and neat appearance, not being distinguishable from the boot or shoe' (*Townsend's Monthly Selection of Parisian Costumes*, 1830).

Changes in men's clothing were less dramatic, but the general style of their dress altered in line with women's fashions. Along with fuller

Plate 29 opposite Women's ankle-length boots. Top (a): Side-laced ankle boot of watered silk with a flat heel and square toe (see plate 30); British or French, 1830s–40s. T.517-1913
Middle (b): Striped cotton jean half-boot with low, stacked heel and rounded toe; British, 1812–20. The boot is laced up the front and trimmed with a silk rosette. T. 509-1913
Bottom (c): Kid half-boot with low, stacked heel and rounded toe; British, 1815–20. The boot is laced up the front and trimmed with a silk rosette. T.435-1971

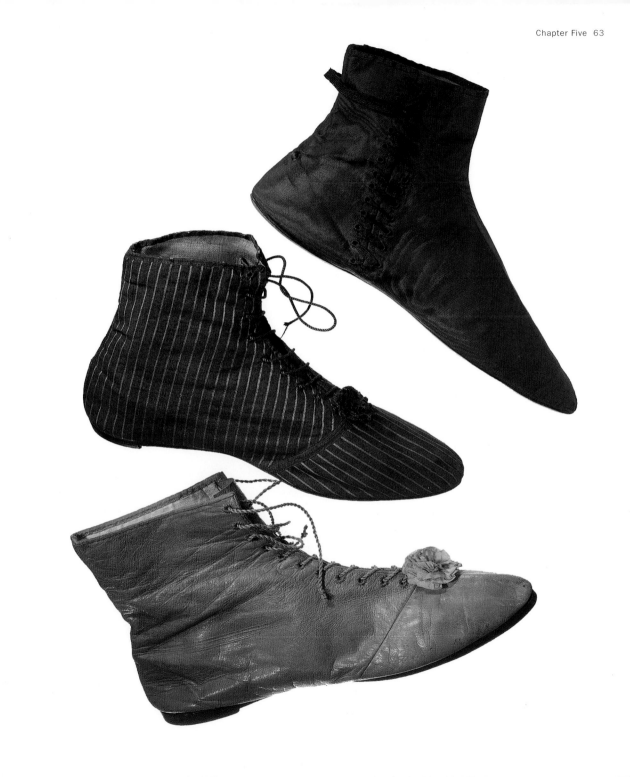

coat sleeves, nipped-in waists and padded coat fronts, men also adopted the shallow, square toe, as seen in fig. 15. Although Wellingtons, Bluchers and lace-tied walking shoes predominated for everyday wear, leather 'pumps' worn with formal evening dress closely ressembled the general shape of women's slippers (see back jacket image and plate 33) with the same long, low and narrow line; according to Prince Pückler-Muskau, who visited London in 1827, they were 'as light as paper'.

Ideals of Beauty: 1800–1837

Men's and women's shoe styles during this period reflected the prevailing ideals of beauty, which equated delicate bone structure with gentle birth and fine breeding. Great attention was paid to the size of the foot and this was sometimes carried to such extremes that the author of *The Whole Art of Dress* remarked: 'frequently in company I have heard the chief beauties singled out among good-looking individuals, were their feet; because, perhaps, they have been rather small and cased in a neat pump'. Narrow half-boots and slippers min- imised the size of the foot, not always with comfortable results: pinching shoes, aching imprisoned feet, toes folded one over the other, bunions, corns and inflamed joints were com- monly cited ailments. Sometimes, even the most rigorous efforts failed to have the required effects. Captain McDonough's *The Hermit in London* (1819–22) described one stout lady's 'sandal' lacings as 'so tight that they crippled her, from which ribbons crossed her ankle and cut it at angles backwards and forwards'.

Neatness was admired as it indicated good taste and gentility. A delicate female foot encased in a close-fitting silk shoe looked

1. *Chapeau de gros de naples. Robe en Chalys.*
2. *Capote en gros de Naples. Rodingote de gros de Naples à petits quadrilles.*

elegant and refined, suiting the ideal image of a woman. New standards of perfection were set for men, and George Beau Brummell achieved lasting fame for his efforts to establish restraint, simplicity and cleanliness in dress during the early nineteenth century. He reputedly paid such meticulous attention to the shine on his boots that their brilliancy was the envy of the finest London dandies. Captain William Jesse, who cultivated Brummell's acquaintance in 1832, remarked that he even insisted on his servants polishing the soles so that the edges would not be neglected. By the 1830s several publications, such as *The Whole Art of Dress* (1830) and *Hints on Etiquette* (1836), had appeared, advising men on the finer points of good dressing, including what they should wear on their feet.

Despite such ideals, badly made and ugly footwear received much comment. James Devlin in *The Shoemaker* (1840) remarked on how many shoemakers were failing to make proper use of a recent technical improvement – the re-introduction of lefts and rights. The development of the pantograph in the early nineteenth century, combined with the return to flat shoes, meant that it was easier to make a mirror image pair of lasts. Shoes cut to the form of the right and left foot therefore gradually began to replace 'straights' (see the red shoe in the back jacket image), although women were slower to adopt them than men. In theory, this development should have ensured a closer-fitting shoe, but according to Devlin the reality was very different. He complained of how the 'light shoe' or 'pump', fashionable throughout the 1830s, 'sits often so loosely along the quarters, and in a most inelegant and injurious hollow curved line...making the foot appear thick and clumsy'.

Plate 30 opposite Fashion plate showing fashionable women's dress of *c*.1832. Hand-coloured engraving; French, *c*.1832. The woman on the right is wearing olive-coloured boots which match the trimmings on her hat and are similar in style to the boot in plate 29a. The woman on the left is wearing black slippers with ribbon ties which closely resemble the style of the yellow shoe shown in the back jacket image. E.1058–1959

Chapter Six

Shopping for Shoes: 1700–1835

So you'll measure me, please, for shoes – and shoes

That will wear for years and years;

And you'll make me a pair that shall fit me well,

Of leather and thread, and – tears.

('Leather and Thread and Tears: A Ballad of Boughton Fair', from

Thomas Wright, *The Romance of the Shoe,* 1922)

Men and women seeking to purchase fashionable footwear had several options at their disposal. Although the actual methods of shoemaking remained largely unchanged until the mechanization of the 1850s, output and retailing rapidly increased to meet the demands of an ever-widening consumer market. By 1700, the origins of the modern shop had emerged: Daniel Defoe, in his book *The Complete English Tradesman* (1726), noted how London shopkeepers were spending large amounts on fitting out their shops with shelves, shutters, 'boxes', glass doors and 'sashes'; 'a modern custom...and wholly unknown to our ancestors'. Shoes were often made and sold under the same roof, but as the century progressed some enterprising shoemakers extended their businesses and began selling their footwear on separate premises. To differentiate between bespoke and ready-made shoes, the former were usually inscribed with the customer's name (see plates 23 and 27a).

People who lived in the provinces often depended on fashion-conscious local shoemakers with London contacts and suppliers. They could also shop by proxy, relying on a friend, relative or trusted retailer to purchase shoes for them. Some even gave commissions to friends travelling abroad, as made-up items could pass through customs as personal clothing and were exempt from the high duties

Plate 31 opposite Woman's leather shoe with a low heel and latchets to fasten over the instep; British, 1810–20. The label on the insole reads 'Borsley Maker, Hanway House, Hanway Street, Oxford Street'. From about 1750 shoemakers began to use labels for advertising purposes, attaching them to both ready-made and bespoke shoes. T.385–1960

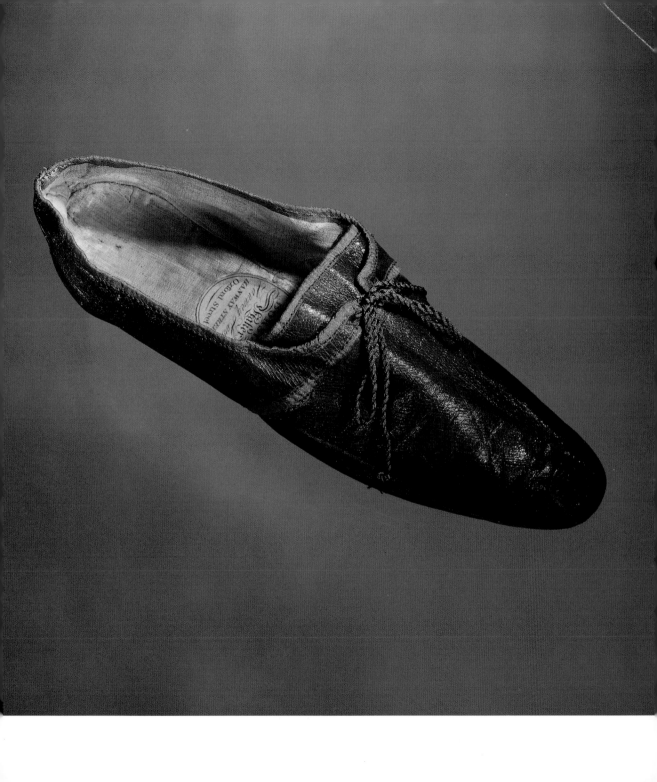

levied on imported goods. *The Letters and Journals of Lady Mary Coke* record how she purchased several pairs of shoes on behalf of a friend in this way, during a visit to Brussels in 1767: 'I went to several Shops, and remembering your having said you wish'd for some painted leather shoes, I bought six pair, which I shall present you with, when I return to England'.

From the 1750s onwards a huge variety of ready-made boots, shoes, pattens and clogs were sold in 'Shoe Warehouses' (see the label in plate 25c). Sometimes warehouses were a sales outlet for a single shoemaker, but more often they served as agents and distributors for a variety of suppliers. Anyone with ready money was welcome to shop there, although they proved particularly popular with the middle classes, offering as they did a wide range of fashionable goods at a reduced cost. Traditional bespoke shoemakers accused these dealers of foisting inferior goods on the public, but shoe warehouses continued to expand despite the protests. They became so widespread that *The London Chronicle* of June 1765 enquired: 'Have we now any shops? Are they not turned into warehouses? Have we not the English warehouse, the Scotch warehouse, the Irish warehouse, the shirt warehouse, the stocking warehouse, the shoe warehouse, the hat warehouse, nay, even the buckle and button warehouse?'.

One of the more traditional ways of purchasing shoes was at markets or fairs. A great shoe-trading event in the seventeenth, eighteenth and nineteenth centuries was the annual 'Boughton Green Fair' in Northamptonshire, when hundreds of prospective customers, rich and poor, poured in from miles around to sample the wares of the renowned Northampton shoemakers. Itinerant salesmen and pedlars also continued to travel from village to town, supplying the countryside with a whole range of goods; they often brought with them buckles and ribbons and sometimes even ready-made shoes.

Chapter Seven

Towards the Modern Age: 1837–1914

Fig. 16 below The Queen
Victoria and Prince Albert
Polka. Baxter Print; British,
c.1840. Both wear flat,
square-toed shoes: Victoria's
are of ivory satin with a bow
and ribbons round the ankle,
while Albert wears patent
leather shoes with a small
metal buckle. The print
employs the contemporary
convention of depicting the
feet as impossibly small,
creating tiny, delicate feet for
Queen and Consort.

E.828-1959

The really well-dressed woman deals in no gaudy confusion of colours – nor does she affect a studied sobriety; but she either refreshes you with a spirited contrast, or composes you with a judicious harmony. (Lady Eastlake [Elizabeth Rigby], *The Art of Dress, The Quarterly Review,* March 1847)

Queen Victoria's accession in 1837 coincided with a change in mood and a more sober taste in dress. Rapid industrialisation was taking place, and the middle classes in Britain and most of Europe had emerged in society as a dominant force in political, economic and social life. Middle-class values and the virtues of hard work and respectability were embodied in the domestic lives of Victoria and Albert, whom she married in 1840. Women's dress portrayed the ideal of modest gentility embodied in the Romantic movement of the later 1830s and 1840s, with its tendency to sentimentalism and nostalgia.

By the late 1850s men's clothes reflected a more relaxed and easy line in keeping with a work-oriented lifestyle. After 1850 a few more practical forms of dress such as separate jackets and skirts also pre-saged women's more active future roles.

Toes and Heels: 1830s–1850s

The gentility of the early Victorian period was reflected in women's shoes, which continued in shape as before (see back jacket), but in more subdued colours. Small hands and feet were associated with gentle birth and suited the contemporary ideal image of women. The foot when it was seen beneath the dress was expected to look small and delicate (fig. 16). Mary Merrifield, in *Dress as a Fine Art* (1854), complained of 'poets and romance-writers' who encouraged women to 'pinch their feet into small shoes'.

Toe shapes for both men and women were square and shallow at the beginning of the period, but by the 1850s they had become deeper for men and thus more practical. Few women's shoes had heels in the 1830s, but by the middle of the century heels had come back into fashion. The delicate but extremely impractical heel-less shoe, usually made of satin, was still popular, with black or white favoured for formal wear. Satin pumps of the kind shown in the back jacket image, although tied round the ankles with ribbons, must have offered little support to the foot.

Generally the height of heels on men's shoes settled at a modest one inch (2.5cms), which is still the norm to the present day. Reflecting the move towards practicality, engendered by a more active lifestyle, the sturdy Oxonian or Oxford shoe became popular for men. This style subsequently became a mainstay of men's shoe fashion and, as described by J. Sparkes Hall in *The Book of the Feet* (1848), it 'laces up the front with three or four holes; the vamp comes well above the joint; seam across the instep. The best shoe for walking'. Shoes or pumps with a low heel and ribbon tie continued to be worn at court or as dress wear, in conjunction with knee-breeches (plate 33).

Plate 32 below left Pair of women's shoes or slippers of linen; British, 1840s–50s. Tongue and upper decorated with silk trim and glass beads. Inscribed inside: 'MARSH Ladies and Childrens Shoe Manufacturer, 148 Oxford Street, opposite Bond Street'. T.734:1&2–1997

Plate 33 below Man's ceremonial or court patent leather shoe with decorative ribbon tie; German, shown at the Great Exhibition of 1851. After the first few years of Victoria's reign, buckles on court shoes (like those seen on Prince Albert's shoes in fig. 16) were abandoned briefly in favour of ribbons. T.257–1963

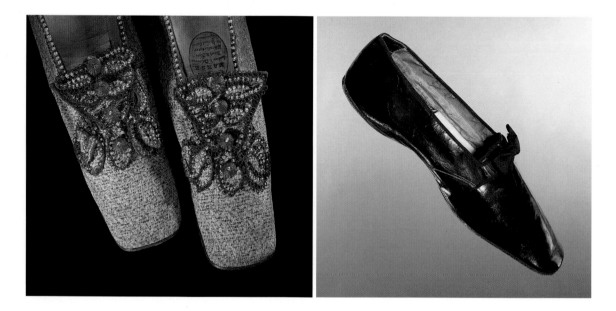

Boots for Men and Women

Boots were still more commonly worn than shoes by men throughout the nineteenth century, and were regarded as more formal for day wear (plate 35). In 1840, James Devlin (see chapter five) observed, 'At present we are emphatically a booted people; so are the French and the Americans'.

Half-boots were popular for men from the 1830s (plate 36c) right up to the Depression of the 1930s. They were more appropriate than long boots for wearing with trousers which, except for more formal occasions, were replacing breeches. After the middle of the century, long boots were rarely worn other than for sport or by the military. For women, half-boots were popular from the 1830s until the 1870s when shoes again predominated. Usually the crinoline completely obliterated the foot, but occasionally the modest boot peeked out beneath it. Side-laced boots with a flat heel were worn by fashion-conscious women. By the 1840s they were made in a range of materials, including leather, which was much more appropriate for country and outdoor wear than lightweight cloth or silk, such as that used in the boots shown in plate 29a.

The elastic-sided boot, a prototype of which was presented to Queen Victoria in 1837 by J. Sparkes Hall, who had patented it, was the result of experiments made with india-rubber cloth (plate 34). By 1846 Sparkes Hall was promoting his 'elastic sided boot', which had 'a cloth upper with a toe cap of black leather'. Gussets of elasticated material were inserted at each side of the boot obviating the need for other fastenings. Elastic-sided boots were popular, but laced and buttoned styles were also fashionable. Side-buttoned boots were popular for men from the 1830s, but adopted more slowly by women. There is a mention in 1858 of 'boots of kid, buttoned at the side' for women.

Other styles for men included Bluchers, with open tab front and lacing, and Alberts, cloth-topped boots with side lacing, which were a short-lived fashion introduced in the 1850s. In Dickens' *Pickwick Papers* (1837), Sam

Plate 34 below Man's elastic-sided boot; British, mid-19th century. Canvas upper with domestic embroidery. T.24–1936

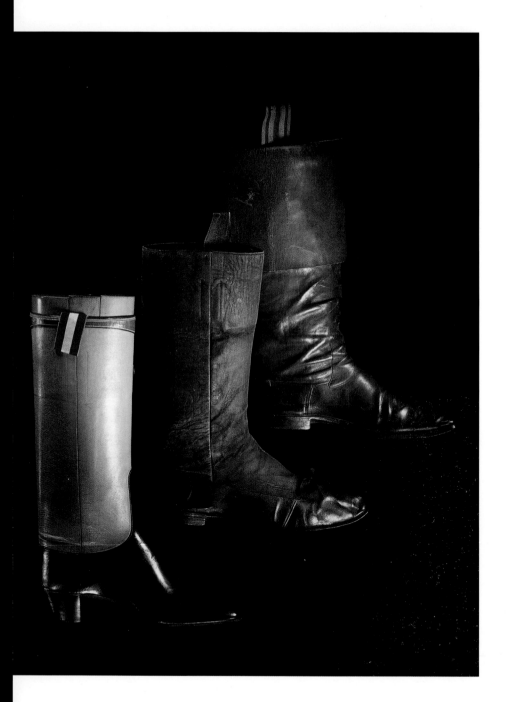

Plate 35 left Men's long boots: Top (a): Leather jockey or top boot with a turn-over top and cloth straps; British, 1820s–30s. This style, which became popular in about 1730, altered very little over a long period, although the shallow, square toe in this example was fashionable during the first half of the nineteenth century. By 1830, top boots had become almost entirely a sporting fashion; similar styles are still worn today for riding. T.599–1913

Middle (b): Wellington (opera boot), leather and patent leather; British, 1840s. Worn under trousers, it would have looked like a pump with a stocking. T.499–1913

Bottom (c): Model boot, leather and patent leather with cloth straps; British, about 1888–90. By Annesley of Brighton. Model boots and shoes were made to show off contemporary styles (such as the rather pointed toe in this example), and the skill of the shoemaker. They were often shown at International Exhibitions and were not intended for wear. T.449–1920

Plate 36 right Top (a):
Woman's model boot, patent
leather and glacé kid with
cork sole; British, 1865–70.
By George Newton. Boots
with curved tops and
tassels, usually cut high
above the ankle, were often
referred to as 'Polish' or
'Hungarian'. T.420–1920
Middle (b): Woman's boot,
patent leather and kid with
decorative stitching; British
or French, 1850s. AP.39–1860
Bottom (c): Man's boot,
patent leather and
snakeskin; British, shown
at the Great Exhibition of
1851. AP.41–1860

Weller had to clean boots described as 'hessians, halves, painted tops, wellingtons' (plates 35 and 36c). Queen Victoria's interest in outdoor life encouraged the wearing of sturdier footwear by women of the higher classes. Named after the queen's Scottish home, Balmorals were boots which laced at the front and were worn by both men and women.

From about the middle of the nineteenth century, increasing numbers of fairly substantial leather boots were being made for women, often with beautiful decorative details such as contrasting coloured leathers or decorative stitching (plate 36). Men's half-boots

Plate 37 left Women's boots. Left (a): Satin boot with applied braid; French? 1860s–70s. T.588–1913 Right (b): Ribbed silk boot, trimmed with bobbin lace and ribbon; British or French, 1865–75. T.180A–1984

of leather were plainer, but could also be made in contrasting colours, although these were generally more subdued than colours used for women's boots. The range of materials for uppers for men's boots and shoes increased, and included snake-skin from about the 1850s (see plate 40) and crocodile or alligator skin in the 1870s.

The stylish Empress Eugénie, who had married the French Emperor Napoleon III in 1853, was a fashion setter, whose clothes and appearance were commented on frequently in the British press. She was probably responsible for the introduction of the shorter skirt which led to a greater emphasis on stockings and shoes. *The Letters of Sir William Hardman* (1862) record that 'The girls of our time like to show their legs...it pleases them and does no harm to us; I speak for the married, not single men'. This trend was not, however, wholly approved of, and it is reported that the Emperor Franz Joseph of Austria, when assisting his Empress and Eugénie into his carriage, remarked quietly but pointedly to his wife, 'Be very careful, Madame, you are showing your feet'. However, the fashion persisted and in 1869 *The Ladies Treasury* commented 'Much more attention is paid to boots and shoes since the introduction of short dresses'.

Paris remained the centre of fashion in Europe until the Franco-Prussian war in 1870. Frivolous boots of silk and satin with high heels were imported from France, although French styles were also imitated by British shoemakers (plate 37). By about 1860, chemical aniline dyes had become widely available, providing a range of bright and often gaudy colours which added vibrant splashes to women's clothing. However, these faded quickly.

Mass Production and the Beginning of Large-scale Retailing

Shoes were being mass-produced by the middle of the nineteenth century. The sewing machine had become proficient for sewing cloth by the 1850s, and a machine for sewing leather was in use by 1856. Other machinery was developed for sewing on soles and for riveting. An example of the increasing impact of mechanization on shoe production is the firm of C. & J. Clark, which bought three treadle machines in 1856 and in 1858, and imported machines for cutting

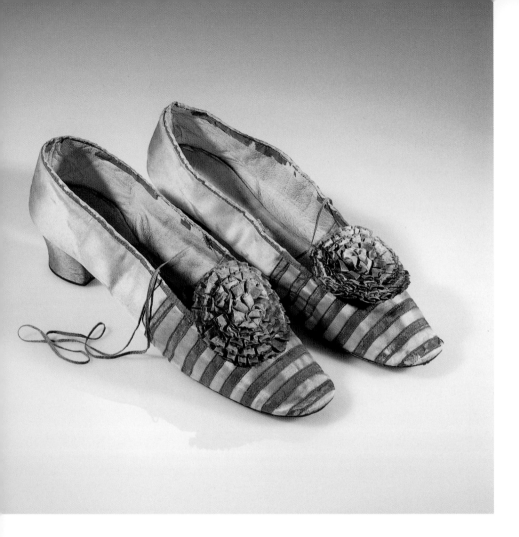

soles from America. Leading shoemaking towns, such as Northampton, were quick to introduce equipment, although most encountered considerable opposition in the early years. Although mass production meant that cheaper footwear became available in greater numbers, handmade shoes retained a particular cachet, as they do now, and men who could afford to continued to buy them. Lilley & Skinner, founded in 1842, were amongst the first shoemakers to combine both wholesale and retail trades, selling their wares through other retailers, and they were to become pioneers of machine production in the shoe trade after the middle of the century.

The Return of the Heel for Women

'As for thin shoes, except for dancing they appear to have vanished from the female toilet', it was noted in *Punch* in 1859. Heels, in fashion again for women's shoes by the 1850s, were initially low, but increased in height to as much as 2$\frac{1}{2}$ inches (6cms) in the 1860s. *The Lady's Magazine* in 1858 refers to 'elastic-sided boots for daywear and evening shoes with or without small heels and rosettes'. Six years later the same magazine described fashions in both boots and shoes as 'For day, with high pegtop heels. The toes nearly square; large rosettes. Evening shoes and boots, white for white dresses, blue or pink with dresses of those colours. Heels 1 inch; large rosettes'.

The low-cut slip-on shoe (plate 38) with a small heel was a forerunner of the court shoe which was to develop fully in the 1870s (see

Plate 38 opposite Pair of women's shoes, satin trimmed with silk ribbon, low heel; British, 1850s–60s. T.562&A–1913

Plate 39 right Woman's mule, low heel, satin with bead decoration; French, 1890s. T.305A–1977

plate 41), and variations of which have continued to be worn ever since. This style was much easier to wear than earlier fashions, and was an indicator of the greater freedom and mobility that some women began to demand as the century progressed. Many women's shoes continued to be made as 'straights' and this tradition was to persist until about 1900.

During the second half of the 1860s, the fashion for crinolines faded out and heavy corseting along with the back bustle came into fashion. These, combined with fashionable high-heeled boots (seen in plate 37), gave the wearer a characteristic posture known satirically as the 'Grecian bend', a name which also applied to the corset itself (fig. 17). *The Queen Magazine* for 14 October 1871 commented on the dangers of high-heeled boots:

Everyone who has noticed the height to which the heels of women's boots is now carried, must have marvelled much how the wearer could maintain her equilibrium, walking on stilts is nothing to it. It may be questioned how far the Grecian bend has become fashionable from a certain power it gives the wearers of the high heel to balance themselves.

Fashionable Casual Wear

The wearing of slippers indoors by women was necessitated by the fashion for boots. Following other shoe styles, heel-less mules or slippers were in fashion in about 1850; by the later 1850s some had heels and from the 1870s onwards the mule with heel was very popular (plate 39). Embroidery, bead-work, canvas-work and tapestry were all used to decorate slippers and mules, as seen in plates 32 and 39.

Men wore mules and carpet slippers. To demonstrate their domestic skills, women could embroider the ready-made uppers of slippers and other footwear for their menfolk (plate 34) as well as for themselves. Patterns for these were readily available, although the results were not always that attractive as the colours produced by chemical dyes, which were much favoured for the embroidery, were very gaudy. Other slippers were far more stylish (plate 40).

In the last quarter of the nineteenth century, there was an extraordinary variety of dress for women which reflected social change and the accelerating pace of fashion. Although the traditional role for women

Fig. 17 below Engraving of a woman in walking dress. From *English Woman's Domestic Magazine*, volume VI–VII, 1869. With a back bustle and high heels, the woman is shown bent forward from the waist in the so-called 'Grecian bend' stance. NAL. PP.19.F

Plate 40 opposite Man's slipper, snakeskin, lined with quilted silk; British, 1850s–60s. AP.6–1868

201.—WALKING TOILET.

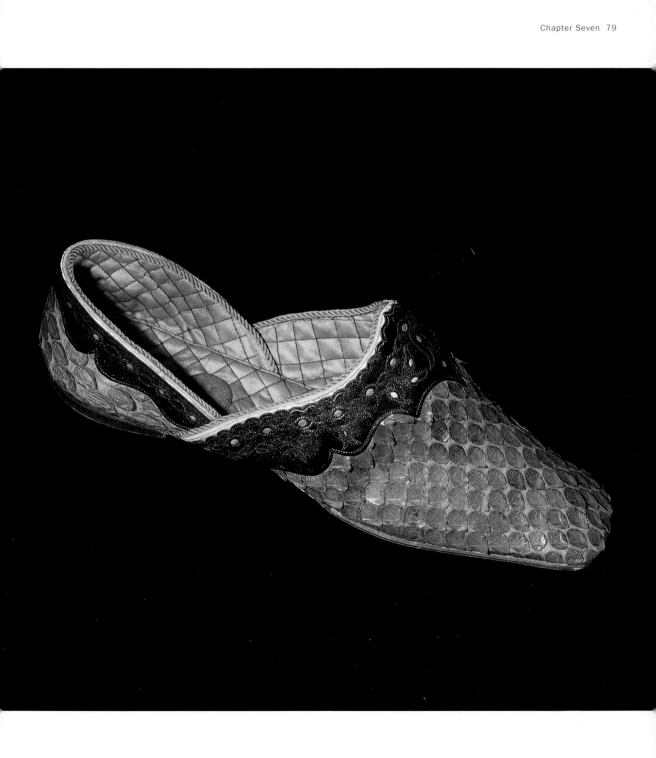

was being re-evaluated, there was still a reluctance to relinquish entirely the protected position they had always enjoyed. Fashions mirrored this ambiguity. There were several major changes in the line of fashionable dress during this period, including the long narrow line of the later 1870s and early 1880s, and an exaggerated bustle shape in the mid-1880s. By 1890 a change to a more horizontal emphasis was shown through fashions for leg-of-mutton sleeves and a stiff flared skirt. Also developing at this time were the more practical tailor-made costumes of matching dress or skirt and jacket. Clothes adapted for sportswear were increasingly in demand. Shoe styles reflected these conflicting attitudes, ranging from the completely impractical to more utilitarian and masculine forms.

Men's footwear, not surprisingly, was generally more sober and practical, reflecting prevailing styles of dress and lifestyle, but details in styling and materials gave them a fashionable edge.

Men's Shoes and Boots

Boots prevailed as fashionable footwear for men, often with stacked heels of about 1–1¼ inches (2.5–3cms) high. Elastic-sided boots (see plate 34) continued to be worn until nearly the end of the century. From 1876 there were indications of the more pointed toe, which developed after 1885. *The Gentlemen's Magazine of Fashion* in 1884 stated that 'modern trousers are close and small bottomed and require narrow pointed boots', and in 1885 *The Tailor and Cutter* described the bottom of trousers as 'cut well up on the boots to show the fancy patent buttoned boots which are now much worn' (fig. 18).

From about 1885 until the end of the century, the fashion for pointed toes showed the influence of American styles. The most extreme point was called 'the toothpick'. From the late 1890s and for the first decade and a half of the new century, the prevailing line for the toe was long, with a small number having the spade-shaped Continental toe. By 1910 the Bulldog or Boston toe had also arrived from America, where it had been fashionable since the late 1890s.

In the last quarter of the century Oxfords and Derbys were the most popular practical lace-ups, and from about 1905 the brogued shoe came into more general use.

Illustration of British Costume,
SUMMER 1885.

Fig. 18 above Man wearing narrow trousers and pointed-toed boots. Plate from *Tailor and Cutter*, volume XX, 1885. NAL. PP.42.B

Shoes Return to Fashion for Women

'The fashion of shoes instead of boots is quite a revolution in female toilets', reported the *Englishwoman's Domestic Magazine* in 1874, and by 1883 the same magazine was declaring 'Boots are scarcely ever seen in town on well-dressed women'. The rather broad and rounded toes favoured by both men and women in the 1870s (plate 41) were succeeded by the female fashion for more pointed toes in the 1880s, already popular in Paris. As the century drew to a close, leather again became fashionable for women's shoes and some masculine styles, including the Oxford, were worn for walking.

In contrast to these practical examples, the heels of stylish shoes reached an extreme of $6^1/_2$ inches (16cms) in the 1890s (dubbed the 'naughty nineties') although, unfortunately, this extreme is not represented in the V&A's collection. One fashionable high-heeled shoe with buckle was called the Cromwell, in the mistaken belief that buckles were favoured in the Cromwellian period (plate 42 and fig. 19). Other styles were called after women in the public eye, including the Langtry, named after the actress Lily Langtry, which was popular in the late nineteenth to early twentieth century. Court shoes, some with bows and often beaded, remained a constant feature throughout the period.

Although there had been reactionary movements against restrictive women's clothing since the 1850s, the ambiguous attitude towards women and their clothes was reflected in the Edwardian period. Until the outbreak of the First World War, the majority of women were still wearing full-length skirts, tightly laced corsets, boned bodices and high-heeled shoes, as confining as any nineteenth-century fashions. Although the very high heel disappeared and was even stated to be 'highly objectionable', both boots and shoes continued to have heels of between 2 and $2^1/_2$ inches (5–6cms), including the Cuban heel (fig. 19), which first appeared in 1904.

Plate 41 below Women's court shoes with low heels. Top (a): Shoe with tapestry-woven upper and small decorative buckle; British, 1870s. The upper was imported from Turkey. From the time of the Crimean War (1854–56), Turkish styles of dress and materials had influenced aspects of fashionable dress in Britain.
T.583–1913
Bottom (b): Ribbed silk shoe with bow; British, 1870s.
T.33D–1932

Overshoes, Country Wear and the Influence of Outdoor Sports

Overshoes were worn by women to protect the flimsy footwear of the 1830s to 1850s. The patten was flat with square toes to match the shoes and had velvet or patent covered leather straps. One form of overshoe made of patent leather and hinged across the ball of the foot was listed on a trade card of 1835, and an example of this type, shown at the Great Exhibition of 1851, is now in the V&A. Overshoes or goloshes of rubber, mainly worn by men, were available for bad weather or outdoor wear and, after the 1830s, soles of india-rubber began to be used for boots. In 1874, Francis Kilvert noted in his diary that he bought a pair of 'ten shilling gutta-percha-soled elastic boots' from Decks of Salisbury.

Shoes with spats and gaiters were fashionable outdoor wear for men and women. Short gaiters or spats which covered the ankles were fashionable for town wear from the 1870s. Sometimes they were made of the same cloth as the trousers but more often of light grey or fawn boxcloth or canvas, with side-buttoning and fastening under the instep with a buckle or strap (plate 43a). In the countryside, cloth and leather gaiters buttoned higher up the leg, like those worn for some sports, gave extra protection.

Plate 42 above Woman's shoe, suede with medium heel and buckle; British, 1905–10. This shape of heel is sometimes described as a Louis heel. T.149–1960

Fig. 19 opposite Advertisement for women's shoes, 1911. V&A Textile and Dress Archive

Plate 43 opposite, right Top (a): Man's boot with gaiters; British, c.1900. T.6A–1970 Bottom (b): Women's boot with gaiters; British, c.1910. From the 1890s until about 1920, it became acceptable for women's boots and shoes to show the foot's natural size, contrasting with the impossibly small sizes that were 'de rigueur' previously. T.147–1960

Some more practical forms of dress had begun to emerge in the nineteenth century as a result of the increasing popularity of sport and leisure activities. Croquet became popular and a magazine (name unknown) of 1867 explained the immense attraction for men: 'One of the chief reasons of the pleasure men take in the game is the sight of a neatly turned ankle and pretty boots'. Tennis was played by women in a blouse and shorter skirt, thus drawing more attention to feet neatly clad in patent leather pumps. A lady wearing 'cycling dress' in the 1890s with knicker-type, knee-length trousers, wore long leggings or boots with buttoned gaiters. Similarly, boots or shoes with cloth gaiters were worn for golf by women in the early 1900s, with a jacket and a skirt which was as much as 6 inches (15cms) off the ground.

Boots and shoes worn by men for sports such as shooting and golf were generally brown, with tan and white favoured in some circles for sportswear. This was adopted in the fashionable two-tone shoe style of the 1930s and 1940s, sometimes known as the 'co-respondent' shoe and seen in plate 50.

Chapter Eight

Austerity and Glamour: 1914–1939

The spirit of practical common sense which has prompted the adoption of
suitable attire for the project in hand, is quite naturally also influencing
modern dress of every description. (*Fashions for All,* December 1916)

The First World War brought about new attitudes towards dress.
Although women had already begun to rebel against unhygienic and
restrictive clothing, war conditions were a catalyst for swifter change.
By 1916 a significant number of women were participating in the war
effort, undertaking a wide range of duties from driving ambulances to
replacing male labour in the factories. The work demanded func-
tional, hardwearing and comfortable footwear. Pictures of elegant and
stylish shoes still graced the pages of fashion magazines, but as the
war continued it was the lower-heeled and sturdier models which
filled the advertising spaces (fig. 20). Shoe manufacturers such as
Delta, Lotus and Manfield & Sons increasingly emphasised the
'dependable quality', 'wear', 'comfort' and 'splendid service' of their
products rather than their chic appeal or decorative qualities.

As the war progressed, extravagance in dress was generally viewed
as unpatriotic and even distasteful. Fashion magazines still encour-
aged women to look stylish to help keep up morale, but they were
careful to distinguish between what they portrayed as vanity and
innate self-respect. Shoes were described as 'quiet but distinctive',
and black remained a dominant colour as so many women were in
mourning. Although official restrictions were less stringent than in the
Second World War (1939–1945), shortages of materials and a luxury
tax on clothes did bring about a degree of economy. 'Cloth-top shoes'
became popular in 1918 due to the scarcity of leather, and the
magazine *Fashions for All* gave instructions on how to make 'pretty

shoe ornaments' from an old pair of paste buttons surrounded 'by a frill of coloured tulle to match the frock' (January 1917).

The Winds of Change

The end of the war brought gloomy prospects for the British shoe industry. Many of its skilled workers had been lost, the economy was in recession, and America had taken a lead in the manufacture of machine-made footwear. Shoe styles altered very little and some companies re-advertised pre-1914 models under different names in an attempt to dispose of old stock. Although the situation was slow to improve, signs of change had appeared by 1920. Hemlines had risen during the years of the war and the new simpler cut of women's clothes gave shoes an even greater prominence. Fashion magazines stressed the importance of smart footwear and pointed out that the wrong shoes could spoil the effect of an outfit. The short-fronted toe became fashionable as it made the foot look smaller (plate 44a), T-bars were introduced and heels increased in height. Chequered designs and appliqué trimmings adorned many shoes, and black was often combined with white or grey in styles worn for half-mourning. There was also a huge range of ornaments to choose from, and iridescent bead insects, gauze butterflies and ornate paste buckles could transform an ordinary shoe into something new and distinctive:

Time was, not so long ago, when women's shoes were for the most part utilitarian, the majority of them boasting but a demure black bow, or plain steel buckle of modest dimensions. Of late years, however, with the increasing variety of material and design in footwear, has come also the greater prominence of the buckle or ornament, and to-day these exist in a profusion greater than ever before (*The Footwear Organiser*, January 1920).

By October 1921 several palatial shoe shops had opened in the West End, and the introduction of stylish new designs increased demand for British footwear abroad. High-heeled shoes with cut-

Fig. 20 above British shoe advertisement, 1916. From *Fashions for All*, June 1916.
NAL. PP.7 AAW

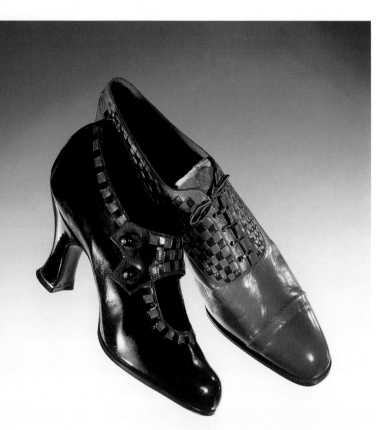

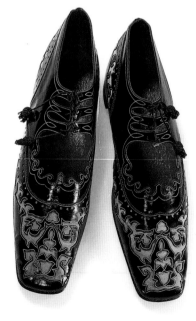

away straps and elongated toes emphasised the elegance of a shapely ankle, and small decorative buckles known as 'fastenettes' provided a chic alternative to the button side fastening (seen in plate 44a). The increasing popularity of novelty designs also infused many styles with a sense of fun. Celluloid heels were produced in tortoise-shell, mother-of-pearl and clouded gold effects, and some were even hand-painted with brightly coloured figures, flowers and birds.

The latest shoe fashions were not to everyone's taste; an article entitled 'Sensible Shoes for Sensible Women. A Challenge to the Industry. By "An Average Woman"' stated that: 'there is a large and an

Plate 44 opposite Left (a): Patent leather woman's shoe, decorated with interlaced leather; British, 1918–20. The bar-strap has two button side fastenings and the toe is short and rounded. T.291-1970 Right (b): Man's shoe decorated with interlaced leather; British (Rushden, Northamptonshire), c.1925. Made by the COX-TON Shoe Company. The name was derived from those of the two company directors: Mr Cox and Mr Newton. T.53-1996

Plate 45 opposite, below Patent leather woman's shoes with intaglio decoration and grosgrain underlay; Italian, late 1920s to early 1930s. Based on the traditional Scottish ghillie. Three tabs project from either side of the instep but in this instance the metal, twisted cord is threaded through eyelet holes and not loops. They have low heels and square toes. T.491&A-1974

ever-increasing number of women, who...prefer health and comfort to appearance, and could not under any pretext be induced to squeeze their feet into...idiotic, high-heeled, unhygienic footwear' (*The Footwear Organiser,* July 1921.) The writer described the 'almost insurmountable difficulties' involved in finding a sensible shoe with a moderate heel that fitted well, looked neat and was moderately priced. Like many others, she refused to 'crib, cabin and confine' her feet in styles that bore no relation to their size or shape, and protested against the 'heavy, ugly shoes with exaggeratedly square toes and thick soles only suitable to wear on ploughed fields'.

Although such complaints were often met with surprise or dismissed, the predicament of the 'average woman' did improve. The growing popularity of sports, and women's more active participation in them, increased demand for comfortable, stylish footwear. By the late 1920s sporting dress had entered the realm of haute-couture and flat, lace-tied shoes, such as ghillies (see plate 45), appeared in *Vogue* magazine alongside more formal high-heeled designs.

In Full Swing: 1924–27

As hemlines rose towards the knee, shoes and stockings became focal points of fashion (fig. 21). In March 1926 British *Vogue* announced:

…shoes are such a perpetually intrusive and interesting subject in this mode that spot-lights the feet and legs that there is always more to be said. For the tailored suit or dress there is the Oxford with its high Cuban heel; for the more formal costume there is still the Oxford, this time with a high spike heel. For those whose ankles are not impeccable there is the less trying high-cut pump or the even more flattering one-strap shoe.

New ranges of footwear captivated the public eye and designs changed radically from one season to the next. Although the bar shoe prevailed, 'low-cut' Oxfords with slender, tapering heels became increasingly fashionable for day as well as evening wear. Daring colour combinations and bold decoration also created new and striking effects, particularly when worn for dancing. Colourful beadwork complemented the beaded fringes on evening dresses, and gold kid ornamented with distinctive motifs (plate 46a) reflected the vogue for

'Oriental' designs. Some shoes were even hand-painted to match the gown (plate 46b), and several footwear companies offered a dyeing service.

Men's shoe styles changed very little compared to the transformations taking place in women's fashions. Black or brown laced shoes continued to predominate and boots remained popular, although they gradually fell out of favour for smarter wear. Many styles were lightly brogued but flamboyant footwear was still frowned upon and etiquette strictly followed. Even shoes of the wrong colour could excite comment, and one etiquette book exclaimed: 'I actually saw a man in the Carlton Hotel entrance hall one night last summer, wearing brown shoes, a dinner jacket, and a straw hat. He was presumably an American, but even so...!' (G.F. Curtis, *Clothes and the Man, 1926*).

Despite prevailing attitudes, the shoes manufactured by the COX-TON Shoe Company (plates 44b and 47) show that there was a market for bold colours and innovative designs. They were displayed at the London International Shoe and Leather Fair in 1925, and may have been intended for the American buyer who was more liberated in his choice of clothing. However, as the decade progressed, the popularity of sports and outdoor pursuits encouraged a more relaxed approach towards dressing in Britain. The Prince of Wales led the way in promoting less formal styles, and his love of golf enabled him to indulge these tastes in the public eye. He was a resplendent figure on the links, and among the many fashions he helped to popularise were two-tone brogues with fringed or shawl tongues.

Thirties Glamour

As the twenties drew to a close, more subtle colour combinations and sleeker designs shaped the style of women's shoes. The tailored look of the 1930s and long sinuous evening gowns demanded an even simpler covering for the foot, and British *Vogue* (March 1935) advised

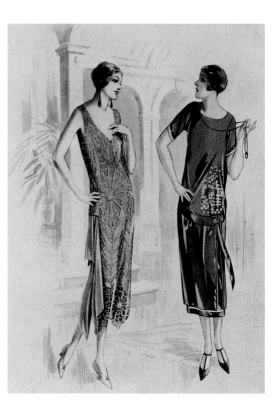

Fig. 21 above Fashion plate from *The Drapers' Organiser*; British, February 1925. The women's afternoon and evening gowns are worn with T-bar shoes (right) and court shoes (left). NAL. PP.9.T

Fig. 22 opposite Shoe advertisement; British or American, 1930s. V&A Textiles and Dress Archive

its readers, 'In planning a wardrobe remember that as clothes make the woman, so accessories often make the clothes'. High-heeled bar and lace-tied shoes remained popular, but clean, elegant lines with discreet trimmings now became the focus of fashion (fig. 22). Dark colours such as 'fir green', 'Havana brown', navy blue and black predominated for daytime wear, complementing the tweeds, flannels and more sombre shades of the tailored garments. Richly coloured velvet (plate 46c), crêpe de Chine and satin shoes were fashionable for evening, often matching the luxurious fabrics of the dresses. Gold or silver piping added elegance to the simplest style, and cut-away lamé shoes set off the glamour of fluid neoclassical-style gowns.

By 1935 sports, fitness and rambling clubs were promoting a greater awareness of physical health, which extended to the well-being of the foot. Manufacturers and beauty editors warned against the dangers of wearing high heels, and set out the ailments caused by rigid or tight-fitting footwear. Although many formal day and evening shoes

remained high-heeled, they were now designed to give the foot greater support. Flatter heels and rounder toes became popular, and many shoe designers experimented with flexible 'ortho-paedic' soles. Leisure wear such as open-toed sandals, previously restricted to the resort, became acceptable elsewhere. In May 1936, for example, *Vogue* ran a feature on smart daytime dresses designed by Edward Molyneux, Jacques Heim and Robert Piguet which included peep-toed shoes with cross-over straps and sling-back heels.

Increasing freedom in dress also resulted in exciting and innovative ideas. In the late 1930s wedge heels and platform shoes swept into fashion, popularised by the Italian designer, Salvatore Ferragamo. Wedges had already been seen on 1920s rubber bathing shoes and resort sandals, but Ferragamo brought this style up to date with modernistic designs, 'spool' heels, and layered cork soles. He also designed extraordinary platform-soled sandals inset with mosaics of gilded glass, encrusted with jewels and covered with rainbows of coloured suede (plate 48). Roger Vivier and André Perugia created equally dazzling styles and soon British *Vogue* was tempting its readers with bulky cork

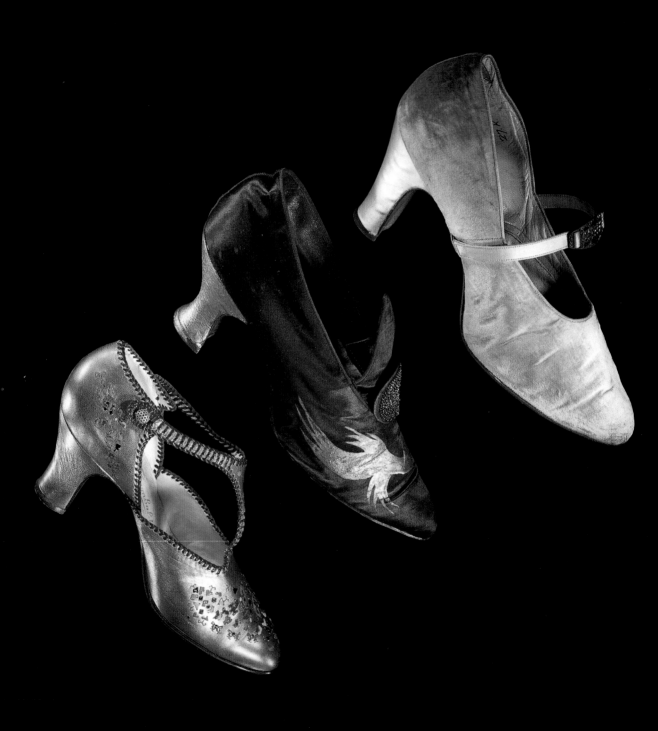

Plate 46 opposite Women's evening shoes. Bottom (a): Leather T-bar shoe decorated with painted motifs; Monaco, *c.*1925. By A. Rambaldi. T.313–1975 Middle (b): Silk satin court shoe with a hand-painted bird motif and beaded ornament; British, 1922. Worn with a matching dress and headband. Made by Stead & Simpson Ltd; the painting was executed by the Misses Parkin. The heel is also painted, and the long pointed tongue is very similar to that in fig. 11. T.737B–1974 Top (c): Velvet shoe with silk satin covered heel and diamanté ornament on the bar-strap; British, *c.*1930. Made by Rayne Shoes Ltd. T.145:1–1997

Plate 47 right Men's shoes made by the COX-TON Shoe Company. Left (a): Shoe of marbled suede with gilt leather decoration; British (Rushden, Northamptonshire), *c.*1925. T.53–1996 Centre (b): Leather shoe with applied gilt leather decoration; British (Rushden, Northamptonshire), *c.*1925. T.56–1996 Right (c): Leather shoe with applied gilt leather decoration; British (Rushden, Northamptonshire), *c.*1925. T.59–1996

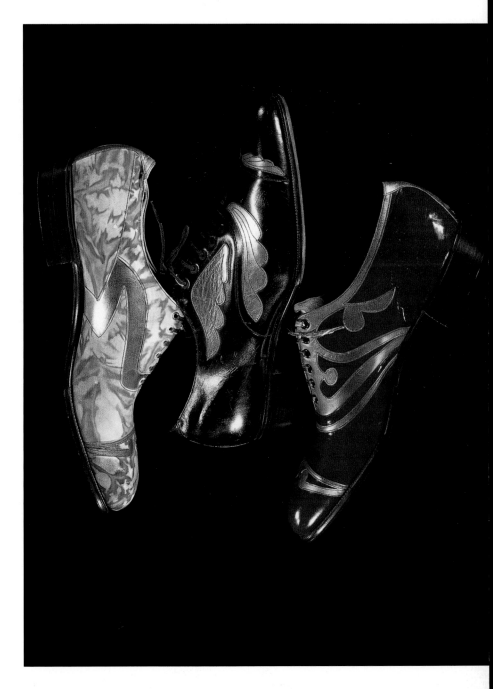

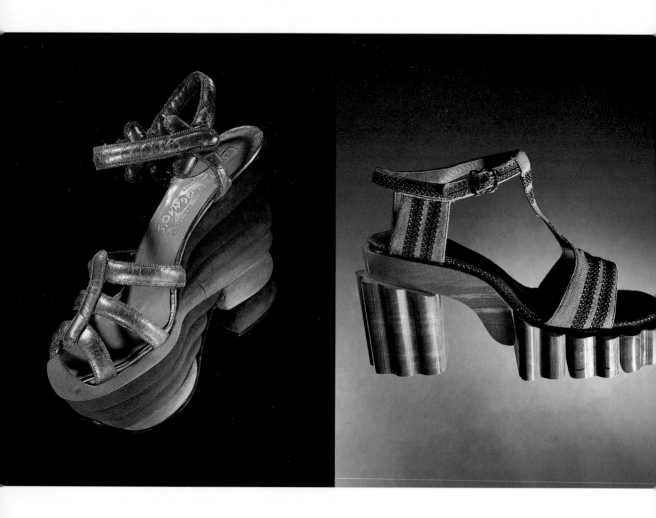

Plate 48 opposite, left
Woman's platform sandal
with padded kid straps;
Italian, 1938. By Salvatore
Ferragamo. The sole is
composed of cork layers
covered with various
coloured suedes. Given by
Sra. Wanda Ferragamo.
T.84–1988

Plate 49 opposite Woman's
sandal with striped canvas
upper and wooden platform
sole; British, *c.*1938. The
front part of the sole is
hinged to give more flexibility
when walking. Part of a
beach outfit, worn with
matching jacket, shorts and
bathing cloak. The insole is
stamped with gilt lettering:
'BUNTING Paris, established
1913 London'. T.301E–1971

Plate 50 right Left (a):
Man's 'two-tone' shoe;
British, late 1930s. Made by
Saxone. Brown leather and
white suede upper with a
pointed toe and low, stacked
heel. T.112–1985
Right (b): Woman's 'two-tone'
court shoe; British, mid to
late 1930s. White buckskin
and brown calf with punched
decoration. T.271–1977

wedges, 'corkscrew heels', hinged soles (plate 49) and chunky 'cut-out clogs': 'It's no sin to call a shoe clumsy, these days. It's a compliment. If you haven't already worn a platform or a wedge sole, do have a pair or two of autumn shoes with this new thick look. Have them to wear chiefly with your street or sports clothes' (October 1938).

Changes in men's footwear were less dramatic. A few new styles developed, such as the casual moccasin, and sandals became more acceptable for summer wear. Two-tone sports shoes continued to offer a flamboyant alternative to traditional Oxford and Derby styles, and by the late 1930s a wider variety of colours and designs was available (plate 50a). Women's shoes also followed this trend (plate 50b), and a Lilley & Skinner advertisement of May 1935 proclaimed: 'You must, of course, have at least one pair of "white and – " shoes. They can even make you look spring-like in your old pleated skirt and jumper, and are invaluable later on to wear with light-weight frocks'.

Chapter Nine

Forty Years of Innovation: 1939–1979

Proper cleaning prolongs the life of leather – and that is now an affair of national importance. Your shoes can last the duration if you pay a good price for them, keep them well polished, correctly treed and regularly mended. (*Vogue,* June 1941)

The Second World War: Women's Shoes

When the war began in September 1939, women were still wearing fashions strongly influenced by Paris. The French capital ceased to be the centre of fashion when it fell in 1940, and Britain turned to New York as well as its own designers for inspiration.

Fashion of the war period was described as 'dictated fashion' and 'purposive but not expressive' by C. Willett Cunnington in *English Women's Clothing in the Present Century,* written from the immediately post-war perspective of 1951. These comments do not allow for the ingenuity of women who, with home dress-making skills and details such as bright make-up, scarves and colourful shoes, could make an outfit expressive of personality and style.

Wartime austerity prevented any complete expression of fashion in Britain, but some innovative and subtly elegant styles of footwear were produced as well as large numbers of practical, flat shoes without any stylish pretentions. Although more serviceable, modest and sturdy than before, the fashionable shoe for this period can nevertheless be seen as a continuation of 1930s styles. Toes which had been rounded became blunter and even square, and the peep toe, regarded as both frivolous and potentially 'dangerous', was banned for fashion shoes until after the war. The wedge heels made fashionable in the 1930s, and also found in modified form on sensible walking shoes, came into much more general use during the war.

Wedges made of cork and wood, harking back to the materials used for the wedge-heeled shoes of the late sixteenth century, replaced the high heels of the 1930s.

Wartime restrictions in the United States were generally less draconian than in Britain; however, shoe designs were under strict limitations and the height of heels was limited to one inch (2.5cms). In Britain two inches (5cms) was the maximum height allowed. Flat shoes and wedge heels complemented the prevailing styles of tailored suits, influenced by military uniforms, and the wide-legged slacks or boiler-suits worn for work or leisure.

British haute couture designers, including Hardy Amies, Norman Hartnell, Digby Morton, Victor Stiebel and Molyneux were closely involved in producing prototype Utility designs for mass production. These were first featured in fashion magazines in March 1942. The Utility scheme had to comply with the 'Making up of Civilian Clothing (Restriction)' orders introduced in spring 1942 which, amongst other things, restricted amounts and types of material used, and fixed prices.

The limitations on style and decoration, dictated both by lack of the usual resources (principally leather) and a sensibility as to what was appropriate for wartime, were balanced by the use of bright and interesting colours, as in a shoe advertised in *Vogue* in 1941: 'High leather shoe, wine, blue, green or black uppers; blue, wine or red wedge and platform sole; zip side fastening. 49/6'.

Inferior grade leathers were disguised with bright hues. Indeed, leather was in such short supply by 1941 that shoes were amongst the commodities traded on the black market. Cheap materials, both natural and synthetic, were utilised on a much larger scale than previously. In addition to low-grade leather, these included cork, wood (as mentioned earlier for heels) and rubber. Strong fabrics, such as canvas, were used for uppers, crêpe was used for soles, and plastic for straps. Many shoes were made of multi-coloured suede remnants and some were made of felt (plate 51). Raffia sandals with cork soles and heels were worn on the beach or for leisurewear. For a short period in 1943 wooden-soled shoes, rated at only two coupons in the ration book, were introduced to 'eke out the nation's leather' (Cunnington). Some

Plate 51 above Pair of women's Utility shoes or slippers; British, early 1940s. Felt and canvas, with wedge heel covered in cotton showing the use of colourful but cheap materials for wartime shoes. The sole is made of a grey composition material, with the Utility mark 'CC 20126 S/W2 4' stamped on it in blue ink.
T.21–1979; T.21A–1979

were hinged across the sole to make walking easier, as certain pattens had been in the nineteenth century.

Extracts from the instructions relating to rationing appeared in the national newspapers on 3 June 1941, explaining the premise of rationing as follows:

Rationing has been introduced, not to deprive you of your real needs, but to make more certain that you get your share of the country's goods – to get fair shares with everybody else. When the shops open you will be able to buy cloth, clothes, footwear and knitting wool *only if you bring your Food Ration Book with you.*

The following extract from the Rationing Table of 1941 shows how shoes were rated compared to other articles of clothing:

Men and Boys	Adult	Child
Coat or jacket, or blazer like garment	13	8
Trousers (other than fustianor corduroy)	8	6
Pair of slippers or goloshes	4	2
Pair of boots or shoes	7	3
Pair of leggings, gaiters or spats	3	2

Women and Girls	Adult	Child
Dress or gown, or frock – woollen	11	8
Overalls or dungarees or like garment	6	4
Pair of slippers, boots or shoes	5	3

Initially the allowance was 66 coupons a year per person but in spring 1942 it was reduced to 60 for 15 months, that is, approximately 48 coupons per year.

Men's Shoes

Fashions in men's shoes continued during the war much as they had previously. In keeping with the spirit of the time, they were modest and practical (plate 52). Men at this time generally had fairly conventional attitudes to clothing, and since large numbers of them were in military uniform, restrictions on footwear did not have the same implications for them as they had for women.

As in the 1930s, men's trousers had a wide leg and to complement this look shoes were heavy duty. Brogues were correspondingly sturdier in the 1930s and 1940s than they had been before. Black was still considered appropriate for town, although brown laced leather shoes were increasingly popular. Suede, previously thought to have 'raffish' connotations, was becoming more acceptable. Two-colour sports shoes were also in fashion. Boots were less fashionable than previously and mostly worn by older men. Gaiters and spats were still in sufficient demand to warrant their listing in the rationing coupons table of 1941.

Plate 52 right Pair of men's Oxford lace-up shoes; British, *c*.1945–50. The instep of the sole has the Utility mark 'CC V3282'.
T.150&A–1980

Plate 53 above left
Woman's shoe with peep-toe
and leather bow; British,
*c.*1947. T.153–1973

Plate 54 left Woman's shoe,
black suede peep toe,
'pearl' ankle strap;
American, *c.*1945–50.
Inscribed inside: 'c.h.baker
california "too smart for
words"'. T.283–1975

Once the war was over (1945), seven styles of demobilisation ('demob') shoe became available. Representing styles popular at that time, all were lace-ups with five pairs of eyelets, as in the Utility shoe shown in plate 52. They included three Oxfords, two Derbys and one brown suede shoe.

Women's Shoes: 1947–1950s

A transitional period in shoe styles for women came after the war, with a return in many respects to the styles of the 1930s. Although rationing continued until 1952, a release from the restrictions on style led to the re-introduction of more frivolous and feminine pre-war styles, such as the peep-toe and high heels (plates 53 and 54). Snub toes were back in fashion and decorative details, such as bows, were added. Ankle boots were also fashionable in the late 1940s, perched on a high, narrowish heel. Sandals with wedges or platform soles were popular summer wear. The sturdy shapes of wartime shoes were thus refined but did not immediately change into the radically pared-back lines characteristic of 1950s and early 1960s high fashion shoes (plate 58).

Men's Shoes Post-war

Rationing and Utility during the war had discouraged extravagance, but although rationing continued after the war, new styles were appearing from 1947. However, traditional lace-ups continued to be the most popular form of men's footwear. In the late 1940s American fashions, notably the 'Zoot Suit', were already appearing in British shops, but it was not until the 1950s that, for the first time in British history, a separate youth culture with its own fashions became established alongside mainstream design. Shoe styles, like other elements of dress, were part of this change. Graduates of the newly established Royal College of Art Fashion Design course in London did not move into couture but into the boutique market. Mary Quant, a fine arts graduate of London's Goldsmith's College, received her only formal training for the fashion world at evening courses in pattern cutting. She opened her first boutique, 'Bazaar', in 1955.

With the fashion for tapered trousers in the 1950s, fashionable shoes generally became narrower at the toe also, corresponding to the

fashion of the preceding decades for wearing chunky shoes with wide trousers. The long pointed toe was an import from the United States, where it was worn in Harlem by black and Hispanic youths. The extremely long Winklepicker was originally worn by working-class youths, and can be compared to the fifteenth-century poulaine (plate 2a), although the 1950s version never reached the extreme length of its medieval antecedent. The style became more widely accepted and Winkle-pickers were also produced by mainstream shoe designers (plate 55).

A complete antithesis to the narrow pointed shoe was the thick, crêpe-soled Brothel Creeper, with strap or buckle fastening, worn with even narrower trousers ('drainpipes') than those of more mainstream fashion. This style became known as the 'Edwardian' or 'teddy boy' look. The more conventional-looking Desert boot, introduced in 1950, was a refined version of the suede, crêpe-soled boots made in Cairo during the Second World War for officers of General Montgomery's Eighth Army, which fought in the North African desert. It, too, was adopted by British youth and worn by 'Mods' in the 1960s. Desert boots have subsequently become a 'streetstyle' classic.

By contrast, a more upper-class 'preppy' look was imported from the United States in the 1950s in the form of the Loafer, a casual slip-on shoe worn by men and women, which became particularly popular in the 1960s.

High Heels

The first New Look suit, 'Bar', designed by Christian Dior in 1947, shows the model wearing the characteristic jacket with nipped in waist and wide, flowing skirt. The ensemble is completed by hat, gloves and shoes with pointed toes and narrow high heels, an early version of the stiletto heel (fig. 23).

Although the fashion world turned again to Paris after the Second World War, the Italians had also become a force to be reckoned with in shoe design. They competed with French designers to slim down

Plate 55 above Man's winklepicker ankle boot; British, *c*.1959–60. Made by Olivers. Leather with gold leather inserts and decorative stitching. T.68A–1978

Fig. 23 opposite New Look outfit, 'Bar', 1947. By Christian Dior. © ADAGP, Paris and DACS, London 1999.

the heel as much as was physically possible. It is not clear who produced it first, but Roger Vivier, Dior's shoe designer, is usually credited with making the first true stiletto in 1954 or 1955. Described as the *talon aiguille* (needle heel), it was reinforced with steel to prevent it from snapping.

In spite of Marilyn Monroe's famous comment, 'I don't know who invented the high heel. But all women owe him a lot' (quoted in *The Sex Life of the Boot and Shoe,* William Rossi, 1976), the stiletto was bad for both wearer and environment, notoriously gouging holes in wooden floors. Stilettos appeared on court shoes and pumps, and the style, although continuing into the 1960s, peaked in about 1958 when Dior introduced the T-strap and wedge toe.

In the 1960s, the centre of the fashion world shifted from Paris to London for both haute couture and streetstyle. Designer shoemakers came into prominence in the 1960s, including Richard Smith who, with Mandy Wilkins, started Chelsea Cobbler in 1967 and later opened a boutique with the same name. Smith created innovative and extravagent designs for a wealthy young clientele, including a pair of cream leather shoes with 'butterfly wings' (*c*.1971), worn by Tolhita Getty and given to the V&A by Mr Paul Getty Junior in 1974.

Classic Men's Shoes

Ankle boots, already back in fashion in the 1950s, remained at the forefront of men's fashionable footwear in the 1960s. The simple but stylish Chelsea boot with elastic sides, first produced in the late 1950s and initially regarded as rather Bohemian, sold in large numbers. It returns to fashion from time to time, including a period in the 1970s, and is a direct descendant of the nineteenth-century elastic-sided boot. The Beatles popularised the Chelsea boot, and made famous another type of ankle boot with side-zip and Cuban heel, which was daringly high for the time. The Desert boot of the 1950s remained popular in the 1960s and 1970s and is now, like the Chelsea boot, regarded as an all-time classic.

Traditional men's shoes continued to be produced, and the beautifully hand-crafted British brogue remained desirable for the discerning male customer. Another classic, worn for formal and evening wear

and based on earlier models (see plate 33), was the low-heeled pump. This continued to be made by established firms specialising in hand-made bespoke footwear, such as John Lobb, and the V&A collection includes a pair worn and given by Cecil Beaton (later Sir Cecil Beaton), dating from around 1960.

Classic and Dashing Designs in Women's Shoes

At the top end of the market, the court shoe remained the classic style for town wear. Since the 1950s, British court shoes had been regarded as the finest in the world. Edward Rayne was one of the leading post-war designers of such traditional styles, which remain in demand for a discerning clientele (see plate 58). The stiletto and other contemporary styles were also included in his range of footwear.

Plate 56 below Selection of heels by H. and M. Rayne Shoes Ltd. V&A Textiles and Dress Department: Rayne archive

Plate 57 right Man's 'space' boot, patent leather with zip fastening; French (Paris) 1967. Part of the 'Cosmos' outfit by Pierre Cardin, Autumn/Winter 1967. T.703D–1974

From the late 1950s lower heels became fashionable and toes longer, giving a foretaste of the revival of 1920's styles which ocurred in the 1960s. At the beginning of the decade, toes became square and heels thicker. Designers such as Roger Vivier and Charles Jourdan produced examples of this type in silk for evening wear, often lavishly decorated and made to match couture ensembles (see plate 59).

The choice of materials for shoes underwent radical changes in the 1960s, partly due to a steep rise in leather prices. Plastics and other synthetics with 'wet-look' finishes complemented the 'space-age' geometric look promoted by fashion designers André Courrèges and Pierre Cardin (plate 57). Courrèges' 1964 'Space Age' collection included flat-heeled, shiny white boots with square toes, which came halfway up the thigh. Mary Quant, one of the most influential British

Plate 58 opposite Women's shoes; British, 1950s–70s. By H. and M. Rayne Shoes Ltd. Far left (a): Green leather sandal, high heeled, *c.*1977–8; Left (b): blue satin 'stiletto' shoe with diamanté trim, *c.*1963; Right (c): Pink leather high-heeled mule, 1979; Far right (d): brown crocodile leather 'stiletto' shoe, late 1950s. V&A Textiles and Dress Department: Rayne archive

Plate 59 right Women's evening shoes. Left (a): Silk shoe with diamanté-studded perspex heel; French, 1967. By Charles Jourdan. T.113–1988 Right (b): Silk satin shoe, trimmed with paste-studded band; French, *c.*1965. By Roger Vivier. T.224B–1976 Bottom (c): Silk satin shoe, with applied gold braid, pastes and sequins; French (Paris), 1952–54. By Christian Dior, Paris. T.147–1974

designers of the period, adopted this idea using injection-moulded plastic. Amongst other styles, she designed square-toed boots cut away at the ankle and bearing the Quant trademark – a daisy – on the heel. Clear plastic shoes were introduced by designers, including the American Herbert Levine, and Roger Vivier. Vivier and other top Parisian designers were by this time responding to new demands and seeking a niche for themselves in the youth market. Vivier's low-heeled Pilgrim pump with silver buckles first appeared in 1962 to accompany the cutting-edge Parisian couturier Yves Saint Laurent's 'Mondrian' collection. It was the most imitated shoe of the 1960s, being sufficiently versatile to appeal to both traditionalists and those looking for new styles.

The mini-skirt burst onto the fashion scene in the mid-1960s, and for the first time a great expanse of female leg was exposed. Boots, both long and short, were the ideal accessory to complement the mini-skirt. André Courrèges and Mary Quant, both of whom have been credited with introducing the mini-skirt, did much to promote the fashion for boots. These became the major fashion feature of the 1960s, initially teamed with the mini-skirt but later in the decade with the maxi-skirt. 'Biba' (the trademark of the designer Barbara Hulanicki and the name given to her boutiques) became synonymous with a wide range of clothes, including long boots in a variety of materials. These were dyed in a wonderful array of sludgy colours ranging from pinks and chocolate brown to plum and subtle mauves (plate 60).

In complete contrast to the rage for boots, very feminine shoes were also in vogue, produced from the early 1960s. Low-heeled pumps, bar shoes, and slightly later shoes with ankle straps became available in a range of mouthwatering colours. These styles, harking back to fashions of the 1920s, were based on ballet and tap-shoes. Like the boots, these were often worn by leggy girls in mini-skirts, most famously by Twiggy (Lesley Hornby), the British model who is so closely identified with the youth fashions of this era.

Fashion in the 1970s was a melting pot of styles. The statement 'Be yourself in fashion and you can live nine lives at once'(*Vogue*, March 1974), captures the mood of the time. At the traditional end of the market, classic shoes for both men and women continued to be

Plate 60 opposite Pair of boots, canvas with platform heel; British, 1969–70. By Biba. T.67&A–1985

produced, while street fashion increasingly diversified. 'Pyschedelic' was a term in current coinage, used to describe subcultural and fashionable styles from around 1967. In the context of clothes and footwear, Art Nouveau revival styles were combined with dayglo colours, which were seen in abundance. Elements of ethnic styles, including Afro-Caribbean and Asian, were incorporated first into hippy fashion and then more widely adopted. The creativity of the early seventies encompassed new fabrics, finishes and shapes, often taking old styles such as platforms and wedges and re-working them. Toes were generally blunt or square.

An advertisement in *Vogue,* May 1971, for three styles of knee-length boots by Chelsea Cobbler – one made of bright towelling patches, the second of cotton Madras check, and the third wedge-heeled with bright stars on lilac canvas – sported the caption, 'What's a nice boot doing in a fabric like this?'. This encapsulated the 'unconventional' aesthetics of the new fabrics and designs, which no doubt made them instantly attractive to the young. Knee or thigh-length boots remained bestsellers, the latter worn with hotpants which were popular from about 1971.

Platforms

From about 1967, shoe designers started to re-introduce the platform shoe, which had gone out of fashion in the late 1940s. In the context of street fashion, platform shoes and boots, worn with bell-bottomed trousers by both men and women, rose to alarming heights by the mid-1970s. Particularly in the setting of the more theatrical rock music performances, such as those of Elton John and David Bowie, they were sometimes as high as 6 or 7 inches (15–18cms). Wedge shoes, teamed with outfits by designers such as Bill Gibb or Zandra Rhodes, made a more subtle fashion statement. Heels and soles were often made of textured fabric, cork or rope, as well as crêpe rubber and leather-covered plastics or wood. Canvas espadrilles, perennial leisurewear, now sported wedge heels and were laced high up the leg. One of the most popular styles of the decade was the mule with uppers in a variety of materials, including patchwork suede, canvas and leather.

Platforms were popularised for women mainly by Barbara Hulanicki (Biba) and for men by Terry de Havilland (see page facing Acknowledgements). He also made women's shoes, and became known for his sparkling, metallic leathers inspired by lurid futuristic concepts. His motto 'Cobblers to the World' vividly expressed the attitude of contemporary young designers, who had scant respect for conventional society but did respect traditional craftsmanship. The high-heeled ankle boot, last in vogue in the late 1940s, was revived in the mid-1970s and stayed fashionable into the 1980s. Peep-toed platform shoes also reflected a more romantic revival from the pre and post-war periods.

An advertisement for real leather, again in *Vogue* (March 1974), suggests that the time had come for the craze to diminish, advocating a more conventional, elegant style: 'Pine green snakeskin shoe with the new, narrow toe, higher, thinner heel and not a sign of a platform'. The oil crisis and subsequent world-wide financial depression led to the advent of more conservative styles from the mid-1970s. Flat and heeled brogues were adopted for smart day-time fashion. Wedges became low at the end of the decade and rather like a clog.

The subcultural movement of punk, with its anarchic, nihilistic attitudes, was particularly influential in the 1970s. Footwear worn by punks ranged from an extreme stiletto for women to chunky crêpe-soled shoes, extreme Winklepickers, and heavy, utilitarian Dr Marten boots (DMs), worn by both men and women. The emphasis was on practicality and aggression. Initially considered outrageous, the influence of punk was soon felt in mainstream and high fashion styling. Vivienne Westwood and Malcolm Mclaren were seminal in the development of this look, bringing it to a wider market.

In sharp contrast with the 'unhealthy' look cultivated by the punk movement, a section of society in the late 1970s coveted a more comfortable and healthy lifestyle. For the first time sturdier shoes like the DM (ironically, in view of its previous associations with punk) as well as sportswear made major inroads into the fashionable dress of both sexes. Sophisticated styles remained in demand too. A healthy and well-tended foot was appropriate to show off the elegant, strappy and bright high heel (plate 58a and c) which had returned by the end of the decade.

Chapter Ten

Shaping the Future: 1980–1998

The shoe is probably the most important of all fashion accessories. You can spend any amount of time and money trying to emulate the glossy pictures in fashion magazines but if your shoes don't match the outfit the image is lost. (Gillian Rowe, 'Getting a foot in the door', *The Guardian,* 22 May 1986)

Dressing for Success

During the image-conscious eighties, fashion was a vital symbol of success. It became chic to flaunt expensive designer wear and many accessories were emblazoned with logos. One of the most powerful icons of status was the man's Gucci loafer with its bold double 'G' motif and band of red and green canvas ribbon. It came to represent the new ease with which wealth was displayed, although cheap imitations and over-exposure eventually weakened the power of the image. The growing popularity of jogging and 'working out' also encouraged a trend for 'designer' sportswear. The name on the trainer had to be Adidas, Puma, Nike, Fila or Reebok and every season saw changes of design which had more to do with style than improving athletic performance. Often trainers were not even worn for sport; women office workers in Manhattan started wearing them with business suits and manufacturers increasingly directed their sales at 'street-cred' conscious urban youth.

The 1980s also witnessed the rise of the female 'power-dresser', whose large shoulder pads demanded 'needle-heel' court shoes to complete the expression of authority. According to advertisements and fashion pages of the day, high heels clicking down the corridors of power were no longer the signal for men to 'swoon' but rather to 'shake'. They were popularised by the shoe designer Manolo Blahnik, who removed the stiletto from its 1970s associations with sex and even prostitution. He imbued the style with extravagance and glamour and his stalagmite-style heels, linguine-thin straps and long

Plate 61 opposite Leather 'mock croc' platform-soled shoes; British, 1993. By Vivienne Westwood. Fastened with silk ribbon laces, which pass through ghillie-style loops and cross over and around the ankle. Worn with a lace blouse, blue velvet cropped jacket, tartan kilt, white rubber stockings and a shocking pink feather boa. Heels: 12 inches (30cm) high. Given by Mrs Vivienne Westwood.

T.225:1&2 –1993

elegant toes inspired one fashion writer to eulogise: 'If Christian Lacroix is the wit and fantasy-maker of fashion, then Manolo Blahnik is the heel and soul' (*Observer,* 7 August 1988).

Although youth sub-cultures such as punks and skinheads continued to rebel against the dictates of conventional dress, a number of their motifs were incorporated into mainstream fashion. The Dr Marten boot (DM) is a prime example of this trend. Introduced into Britain during the 1960s as work wear, skinheads incorporated the 16-eyelet cherry-red DM into their aggressive look, and other designs later became a component of punk style. By the early 1980s, however, the DM had been elevated to the international catwalks. Japanese designers Yohji Yamamoto and Rei Kawakubo accessorised their collections with chunky DM black leather shoes, turning a functional product into a high fashion icon. DMs subsequently became accepted as streetwear for a wider youth market, and during the late 1980s were paired with flouncy feminine clothing in a defiant gesture of feminist assertiveness. Today they are a versatile product, worn as much for comfort as for style by a socially diverse market.

Recycling and Retro-chic

During the recession of the early 1990s fashion shifted away from conspicuous consumption. Haute couture, high-investment goods continued to sell well, but the brash, invasive designer label was no longer all important. Sub-cultural and ethnic clothing styles became increasingly fashionable, and many designers profited from the burgeoning interest in ecology. Chunky cork sandals by Birkenstock and shoes made from leather substitutes which allowed the foot 'to breathe' became the ultimate in trendy 'natural' footwear. The desire to return to the great outdoors, or at least to look as if you did, boosted sales of hard-wearing hiking boots such as Timberlands, Caterpillars and Rockports. Growing concern for the environment also encouraged some shoe manufacturers to diversify into producing ranges of footwear made from recycled materials.

Whilst the eclectic range of styles continued to increase, each season witnessed discernible trends. The seventies revival in 1992–93, for example, brought back what has been referred to as the 'Old

Plate 62 opposite Brocaded silk shoes; British, 1996. By Manolo Blahnik. The floral design is similar to patterns on early 1750s silk. Given by Mr Manolo Blahnik.
T.158:1&2–1996

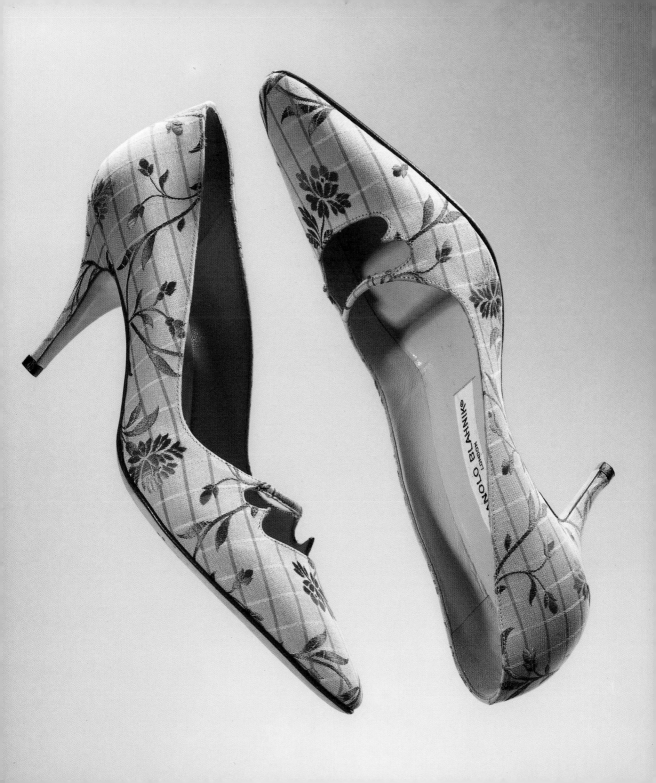

School' variety of trainer. The Puma Clydes and Adidas Gazelles, as worn on the playing field in the 1970s, were heralded as the new cult sneaker. Supermodel Kate Moss declared she owned five pairs, and fashion designer Helmut Lang accessorised his 1993 Winter collection with Stan Smith trainers with the logos painted out.

Despite their associations with aching limbs and twisted ankles, platform shoes also made a sensational comeback in the early 1990s. Vivienne Westwood first re-introduced the platform onto the catwalk in 1984, when her models fought over who should wear the three pairs of 6 inch (15cm) soles that Patrick Cox had designed for the show. She was, however, ahead of her time. The high platforms which formed part of her 1985–86 'mini crini' collection did not make a particularly favourable impact on the general public. By 1992, however, other designers were following her example and chunky soles featured prominently in collections by Yves Saint Laurent, Jean-Paul Gaultier, Prada and Karl Lagerfeld for Chanel. Newspapers and magazines ran full-page features on the return of the 'skyscraper sole' and platforms were cited as an ideal partner to the new, long, pencil-thin skirts. Despite the growing popularity of platforms, it was still Westwood who produced the most outré designs. She challenged convention yet again with her staggering 'mock-croc' platforms with 12 inch (30cm) heels, which she designed for her 1993 Anglomania collection (plate 61). The shoes achieved even greater notoriety when supermodel Naomi Campbell tumbled over in them, on the Paris catwalk.

The 'Fashion Forward' Shoe: a New Generation of Shoe Designers

Despite the emphasis on mass production and standardisation, many shoe designers have continued to produce original and exciting designs using traditional formulae. The name of Manolo Blahnik, for example, is synonymous with perfectly crafted women's shoes (plate 62). Having trained as an artist, he took up shoemaking in the early 1970s and soon became a leading London-based designer serving international markets. As well as relaunching the high heel, his innovative approach towards cut combines comfort with style and his beautifully sculpted designs can make the widest foot look sleek and

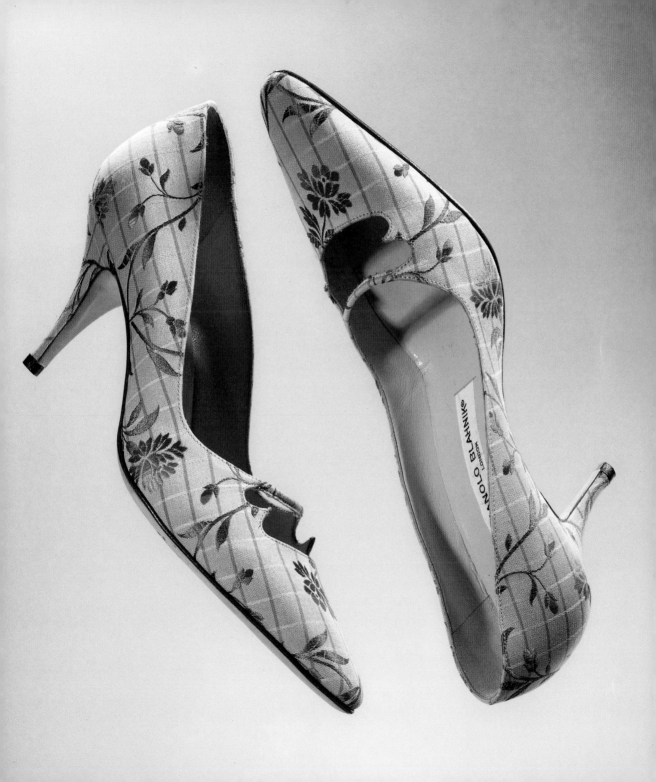

School' variety of trainer. The Puma Clydes and Adidas Gazelles, as worn on the playing field in the 1970s, were heralded as the new cult sneaker. Supermodel Kate Moss declared she owned five pairs, and fashion designer Helmut Lang accessorised his 1993 Winter collection with Stan Smith trainers with the logos painted out.

Despite their associations with aching limbs and twisted ankles, platform shoes also made a sensational comeback in the early 1990s. Vivienne Westwood first re-introduced the platform onto the catwalk in 1984, when her models fought over who should wear the three pairs of 6 inch (15cm) soles that Patrick Cox had designed for the show. She was, however, ahead of her time. The high platforms which formed part of her 1985–86 'mini crini' collection did not make a particularly favourable impact on the general public. By 1992, however, other designers were following her example and chunky soles featured prominently in collections by Yves Saint Laurent, Jean-Paul Gaultier, Prada and Karl Lagerfeld for Chanel. Newspapers and magazines ran full-page features on the return of the 'skyscraper sole' and platforms were cited as an ideal partner to the new, long, pencil-thin skirts. Despite the growing popularity of platforms, it was still Westwood who produced the most outré designs. She challenged convention yet again with her staggering 'mock-croc' platforms with 12 inch (30cm) heels, which she designed for her 1993 Anglomania collection (plate 61). The shoes achieved even greater notoriety when supermodel Naomi Campbell tumbled over in them, on the Paris catwalk.

The 'Fashion Forward' Shoe: a New Generation of Shoe Designers

Despite the emphasis on mass production and standardisation, many shoe designers have continued to produce original and exciting designs using traditional formulae. The name of Manolo Blahnik, for example, is synonymous with perfectly crafted women's shoes (plate 62). Having trained as an artist, he took up shoemaking in the early 1970s and soon became a leading London-based designer serving international markets. As well as relaunching the high heel, his innovative approach towards cut combines comfort with style and his beautifully sculpted designs can make the widest foot look sleek and

narrow. He is also a master of colour, using vivid combinations of magenta, scarlet, bright orange, emerald green and saffron yellow to striking effect. Drawing inspiration from a variety of sources, he can capture the spirit of Georgian grace in a contemporary design or even the sensation of a smell:

Once, for example, I was driving through the South of France with George, my New York partner, and I said, 'George, stop the car immediately, right now!' We screeched to a stop, and there was this wonderful smell of mimosa mixed with jasmine, and from that I made a shoe ('Footnotes from Manolo Blahnik', *Vogue,* September 1990).

He continues to refine the seductive line of his shoe, and endowed the stiletto of the 1990s with a new sensuality and sensitivity.

Since the mid-1980s, a new wave of British shoe designers has linked the Cordwainers College in East London with innovation and style. Emma Hope was one of the first graduates to attract publicity, producing shoes under her own label in 1985. Her beautifully embroidered designs and 'elfin' pumps perfectly complemented the British love of dressing up (fig. 24). She designed footwear for Betty Jackson and English Eccentrics, matching their exuberant and exotic trends with her soft sculpted lines, elongated toes and romantic designs. Whilst historical influences remain vital to her unique sense of style, Hope is constantly original in her approach. Her sleek, velvet slippers, strappy evening shoes and slinky high-heeled mules have a modernistic appeal tinged with a sense of British nostalgia.

Another popular and enormously influential designer is Patrick Cox. Canadian-born, he launched his career while still enrolled at the Cordwainers College, creating radical designs for Vivienne Westwood in 1984 and Body Map in 1985. Cox's fleur-de-lis signature has become a symbol of avant-garde design as well as top quality workmanship. He has re-interpreted traditional men's footwear, such as the co-respondent shoe, and experimented with moulded plastic jelly sandals, embedding models of the Eiffel tower into the heels. He is also known as the hero of the 1990s loafer. He created his Wannabe range of chunky loafers for the Autumn/Winter 1993/94 collection (plate 63) and the style became so popular that a doorman had to be

Fig. 24 above 'Josephine Baker' shoes; British, 1988. By Emma Hope. Black velvet with red and beige appliqué work and yellow and black beads representing bananas and hair. Embroidery by Karen Spurgin Winter. These witty shoes personify Josephine Baker (1906–75), the celebrated international singer and dancer known as the 'Black Goddess' of cabaret, famed for her spectacular revues which included dancing on a mirror at the Folies Bergère wearing nothing but a string of rubber bananas around her waist. Given by Ms Emma Hope. T.157:1&2–1990

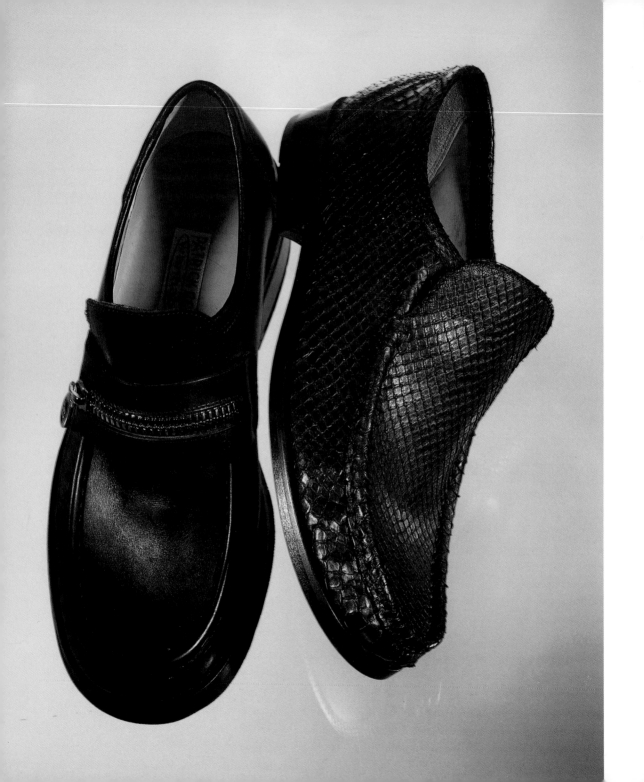

employed to manage the queues that formed outside his London shop. As Cox explained in a BBC radio 4 interview in 1997, the appeal of the Wannabe lies in its versatility:

I think the success of the Wannabe loafer is the comfort factor and the cult that built around it...the comfort is key because footwear trends come and go, strappy sandals, pointy toes...but they're trends and they're fads and they die, but with the Wannabe loafer, even if you don't want to wear them any more because one too many of your friends have them or too many pop stars wore them that week...you end up wearing them because they are so comfortable.

By 1996 he had designed a range of Wannabe clothes and accessories to go with the shoes, and 'the global image' remains a vital component of his style. In his Autumn/Winter 1998 collection, metallic snakeskin loafers (plate 63a) complement the futuristic look of the men's suits, while on other shoes velcro fastenings and zips (plate 63b) reflect the functional details of the sportswear tops.

For Jimmy Choo shoemaking is a mixture of sculpture and engineering (plate 64). He learnt the art and intricacies of the craft from his father, a Malaysian shoemaker, and came to London in the early 1980s to study footwear design. After graduating from Cordwainers College with a distinction he launched his own label in 1988. Since then he has produced exquisite shoes for major fashion designers, including Jean Muir, Katharine Hamnett and Bruce Oldfield, as well as a large international clientele. The actress Kate Winslet was apparently so taken with the lace-up boots that she wore in the film of *Sense and Sensibility* (1995), that she ordered some shocking pink satin shoes to match her Vivienne Westwood dress for the Hollywood Oscars ceremony. Although he introduced a ready-to-wear range in 1996, Choo's real passion is the made-to-measure shoe. Based in a small workshop, he designs footwear to match his clients' specifications, often advising on style; he will not, for example, create a heel that is over $4^1/_2$ inches (11cms) high. His sleek, elegant creations have been described as 'shoes for princesses with chauffeur-driven transport'. The late Diana, Princess of Wales, wore them for special occasions, and by publicising the work of designers such as Jimmy Choo she did much to promote the couturier shoe industry.

Plate 63 opposite Two men's Wannabe loafers by Patrick Cox. Right (a): Brown metallic-effect snakeskin; British, Autumn/ Winter Collection 1998. T.181–1998 Left (b): Black leather with zip over the instep; British, Autumn/Winter Collection 1998. Given by Mr Patrick Cox. T.182–1998

Plate 64 left Pink satin mules with silver insoles; British, Summer 1998. Designed and created by Jimmy Choo, especially for the V&A. T.284:1&2–1998

Plate 65 opposite Men's 'Soho' chukka boots; British, 1998. By Oliver Sweeney, from the 'Sweeney's' Collection. 'Pascagoule' brown leather with hand-stitched 'S' logo on the upper and blue leather lining. Given by Mr Oliver Sweeney. Photograph by Jeremy Hirsch; reproduced by kind permission of Oliver Sweeney Ltd. T.285:1&2–1998

Tradition and Innovation

Shoe trends come and go. Some styles are fairly constant, while others, too extreme to be fashionable for long, die or re-surface in a different form. Strappy sandals, high heels, boots, loafers and brogues have remained popular, but designers are constantly re-working the basic shapes to give a modern appeal. Oliver Sweeney, creator of a stylish range of hand-crafted footwear, has been described as 'the finest designer in the world of classic-with-a-twist men's shoes' (*The Independent,* 3 April 1993). Sweeney has revitalised the image of the Oxford, Derby and brogue through subtly combining traditional bespoke techniques with a flair for contemporary design (plate 65). Each shoe is modelled from a unique anatomical last, originally developed by Sweeney himself, and together with proper arch supports this ensures a sleek modern design: 'Most brogues have a countryish,

slightly bulbous look to them…If the arches are held tightly, it makes the feet look long and narrow, instantly elegant' ('A walk on the classic side', Oliver Sweeney, *The Times,* 11 June 1991). His Storm Derby became something of a cult fashion shoe in the early 1990s, and he continues to re-interpret classic styles using squared-off toes, thick welts and a distinctive streamlined cut.

Technological advances, particularly in the sportswear industry, continue to exert a powerful influence on shoe design. Specialised

Plate 66 left Woman's 'Elast' ankle boots with square toes; Italian, Spring 1998. By Armando Pollini. Given by Mr Armando Pollini. T.84:1&2–1998

Plate 67 opposite Women's shoes, 'Clovis'; French, 1995. By Christian Louboutin for his Spring/ Summer Collection 1995. The hydrangea petals suspended in the Lucite resin sole were gathered from Louboutin's garden and then hand-dried. Given by Mr Christian Louboutin. T.729:1&2–1997

sports shoes made of high-performance techno-fibres and reflective materials have fed into mainstream fashion, and designer versions by Donna Karan's DKNY line have become the ultimate in trendy streetwear. The latest technology has also enabled many shoe designers to experiment with a vast range of synthetic materials as well as new methods of construction.

Others have explored existing sources to create innovative and exciting footwear. Armando Pollini's discovery of the stretch fabric, 'Elast', transformed the appearance of the ankle boot (plate 66). He stumbled across the stretch grosgrain in 1985, while sourcing new materials in a German firm which made corsets and bustiers. He patented the fabric under the name 'Elast', using it to create a range of close-fitting yet supple court shoes, loafers and boots. The vibrant colours and rich textures of the material complement the sculpted lines of his ankle boots, giving them a strong minimalist look. His work has been widely imitated but, as Pollini points out, 'the quality is absolutely not the same'.

French shoe designer Christian Louboutin is no stranger to innovation. After working as a freelance designer for Chanel and Charles Jourdan, he opened his first shop in 1991. Although his shoes are always extremely feminine he often combines chic elegance with theatrical fantasy to create novel and provocative designs. His most exuberant creations include gilded heels carved to resemble Assyrian columns, and a pair of mules with 'bra-strap' fastenings, inspired by the Serge Gainsbourg song, 'Sea, Sex and Sun'. He has even suspended hydrangea petals in clear resin to give the impression of walking on a carpet of flowers (plate 67): 'Gardens are a great inspiration for me...some designers might go to a Gauguin exhibition and say "Wow, what a beautiful blue", but when I close my eyes I see shades of colour from gardens instead' (Christian Louboutin, *Impression 'Sole Man'*, November 1995).

It is impossible to foresee what innovations shoe design of the future will hold. Perhaps the words of Patrick Cox best sum up the outlook of many young designers. When asked 'What comes next?' in a recent internet interview with *Vogue,* he responded, 'God, we've only just started!'

Glossary

Note: The use of the word 'shoe' also includes boots, slippers, chopines, trainers and overshoes, unless otherwise stated.

Albert side-laced boot with five buttons and usually a cloth top.

Artois buckle shoe buckle of enormous proportions, fashionable in the 1770s and 1780s. Named after the Comte d'Artois, later Charles X of France (1824-30).

Balmoral closed-front ankle boot with galosh. Worn by men and women, named after the country seat of Queen Victoria.

Blucher short, front-laced leather boot, named after the Prussian General von Blücher who played a decisive role in the Battle of Waterloo in 1815.

Brogue a laced shoe with punched decoration.

Brothel Creeper shoe, usually of suede, with thick crêpe sole.

Bulldog or Boston toe bulbous toe shape on men's shoes, popular in the United States during the late 19th century and in Britain in the early 20th century.

Buskins boots reaching to the calf or knee, usually made of supple or lightweight material.

Chape the pronged part of a buckle through which the strap is secured.

Chelsea boot ankle boot with pointed toe and elastic sides. Popular during the 1960s and associated with the fashionable King's Road in Chelsea, London. Also known as the Beatle boot.

Chopine see mule.

Chukka boot man's lace-tied ankle boot. Originally worn by polo players; adopted for general wear in the 1950s.

Clog leather-soled overshoe with straps across the instep, sometimes made to match the shoe with which they were worn.

Court shoe a low-heeled, slip-on shoe.

Cromwell medium or high-heeled shoe with decorative buckle.

Cuban heel heel of medium height with slightly curving back.

Derby lace-tied shoe with eyelet tabs stitched over the vamp.

Desert boot front-laced suede ankle boot with crêpe sole, a refined version of those made in Cairo during World War II for General Montgomery's Eighth Army.

Eyelet tabs front facings of the shoe through which the laces are tied.

Fastenette small buckle used to fasten the strap over the instep, often decorated with pastes. Served the dual purpose of a working buckle and an ornament.

Gaiters cloth or leather coverings for leg and ankle, buttoned or buckled at the side and often held on by straps under the foot.

Galoshes/goloshes/galoches overshoes worn outdoors to protect the boot or shoe.

Ghillie shoe of Scottish origin, with lacing through loops instead of eyelets.

Horned toe 16th-century shoe with two small horn shapes at the toe.

Hose a type of leg and foot covering, a precursor of the stocking.

Instep the raised area on the top of the foot above the toes.

Jackboots a) heavy, hard leather boots often with bucket tops to cover knees, worn for riding or outdoors; b) lightweight boots with back of knee scooped out to allow for bending.

Jelly sandal shoe made of soft plastic, with the bright, translucent look of jelly.

Jockey boot (later known as a top boot) leather boot with a turnover top and cloth straps. Originally worn for horse-racing, and adopted as fashionable wear during the eighteenth and early nineteenth centuries.

Langtry shoe of medium height, similar to the Cromwell but with a strap fastening or a large bow instead of a buckle. Named after the actress Lilly Langtry.

Lappets two bands of lace or linen hanging from the back or sides of a woman's cap. Popular from the late 17th century to the late 18th century, and again in the two middle quarters of the 19th century.

Last carved or moulded form on which the shoe is made.

Latchets straps which fasten across the instep by means of a shoe-tie or buckle.

Loafer casual slip-on leather or suede shoe, originating in the United States.

Louis heel heel of medium height, sharply curving inwards at the back, front and sides, and flared slightly at the base. Probably named after Louis XV.

124

Mule/pantoble/chopine types of shoe without heel quarters.

Oxford lace-tied shoe with eyelet tabs stitched under the vamp.

Pantoble see mule.

Patten overshoe with a wooden sole raised on an iron ring.

Pelisse an outer garment or coat.

Pinchbeck copper alloy which simulates gold. Invented by Christopher Pinchbeck in the 1720s.

Pinked decorative cut with saw-toothed edge.

Pump shoe with thin sole, soft or patent uppers and flat heel.

Quarter part of the shoe upper covering the sides and back of the foot.

Rand narrow strip of leather between the upper and sole, sometimes used as a decorative feature.

Slipper name for a mule which was in use from the later 17th century onwards.

Spats short cloth or leather gaiters.

Spool heel a heel composed of convex layers resembling the top and bottom outer edges of a cotton reel.

Stacked heel heel built up of horizontal layers of leather.

Straights shoes not shaped to distinguish between left and right, so could be worn on either foot.

Throat shaped part of the vamp resting on the instep of the foot.

Tongue part of the vamp which extends under the latchets or eyelet tabs.

Trainer sports shoe which has developed into a fashion accessory.

Two tone or co-respondent type of two-colour shoe originally worn for golf. It was adopted for more general wear in the 1930s and became known as the co-respondent probably because of its association with 'flashy' men of the type then cited in divorce cases.

Upper the part of the shoe which covers the top of the foot.

Vamp the front section of the shoe upper covering the toes and part of the instep.

Vandyked edge a serrated edging of lace or other material.

Wellington leather boot similar to the top boot but without the turnover top. Some styles have 'stockings' attached. Named after the 1st Duke of Wellington, famous for his part in the Battle of Waterloo in 1815.

Welt a narrow strip of leather sewn around the edge of the upper and insole to help attach the sole.

Winklepicker shoe with excessively pointed toes.

Major UK Dress Collections Featuring Shoes

Central Museum and Art Gallery, Northampton

Gallery of Costume, Platt Hall, Manchester

Museum of Costume, Bath

Museum of London, London

Shambellie House Museum of Costume, New Abbey, near Dumfries, Scotland (displays of costume from the National Museums of Scotland)

Shoe Museum, C&J Clark Ltd., Street, Somerset

Victoria and Albert Museum, London

Selected Bibliography

An Outline History of Footwear - The shoe as a mark of civilization and as an objet d'art. International Shoe Museum, Romans, France, 1996.

Arnold, Janet *Queen Elizabeth's Wardrobe Unlock'd*. W.S. Maney & Son Ltd., Leeds 1988.

Brooke, Iris *Footwear - A Short History of European and American Shoes*. Pitman, London 1972.

Buck, Anne *Dress in Eighteenth Century England*. B.T. Batsford Ltd., London 1979.

Byrde, Penelope *The Male Image – Men's Fashions in England 1300–1970*. B.T.Batsford Ltd., London 1979.

Byrde, Penelope *Nineteenth Century Fashion*. B.T. Batsford Ltd., London 1992.

Campbell, R. *The London Tradesman*. T. Gardner, London 1747 (reprinted 1969).

Catalogue of shoe and other buckles in Northampton Museum. Northampton Borough Council Museums and Art Gallery, 1981.

Chenoune, Farid *A History of Men's Fashions*. Flammarion, Paris 1993.

Costume The Journal of the Costume Society. Costume Society Publications, Leeds. Specific issues: Number 11 (1977), pp.28–33, Thornton, J.H. *A Glossary of Shoe Terms*. Number 18 (1984), pp.35–58, Buck, Anne and Matthews, Harry. *Pocket Guides to Fashion*. Number 22 (1988), pp.44–50, Swann, June. *Civil Uniform and Court Shoes in Northampton Museum*. Number 22 (1988), pp. 51–59, Du Mortier, Bianca M. *Men's Fashion in the Netherlands*. Number 26 (1992), pp. 32–39, Fawcett, Trevor. *Bath's Georgian Warehouses*. Number 31 (1997), pp. 49–67, Llewellyn, Sacha. *'Inventory of her Grace's Things, 1747' – The Dress Inventory of Mary Churchill, 2nd Duchess of Montague.*

Cunnington, C. Willett *English Women's Clothing in the Nineteenth Century*. Faber & Faber Ltd., London 1937.

Cunnington, C. Willett & Phillis *Handbook of English Mediaeval Costume*. Faber & Faber Ltd., London 1952.

Cunnington, C. Willett & Phillis *Handbook of English Costume in the Sixteenth Century*. Faber & Faber Ltd., London, first published 1954.

Cunnington, C. Willett & Phillis *Handbook of English Costume in the Seventeenth Century*. Faber & Faber Ltd., London, first published 1955.

Cunnington, C. Willett & Phillis *Handbook of English Costume in the Eighteenth Century*. Faber & Faber Ltd., London, first published 1957.

Cunnington, C. Willett & Phillis *Handbook of English Costume in the Nineteenth Century*. Faber & Faber Ltd., London, first published 1959.

Cunnington, Phillis & Mansfield, Allan *Handbook of English Costume in the 20th Century 1900–1950*. Faber & Faber Ltd., London, 1973.

De la Haye, Amy (ed) *The Cutting Edge: 50 Years of British Fashion 1947–1997*. V&A Publications, London 1996.

De Marly, Diana *Fashion for Men – An Illustrated History*. B.T. Batsford Ltd., London 1985.

Defoe, Daniel *The Complete English Tradesman*. Charles Rivington, London 1726.

Devlin, James *The Shoemaker - Guide to Trade*. Houlston & Stoneman, London 1840.

Dowie, James *The Foot and its Covering; comprising a full translation of Dr Camper's work on 'The Best Form of Shoe'*. Robert Hardwicke, London 1861.

Fashions for All - The Ladies' Journal of Practice Fashions. London 1912-17.

Grew, Francis and de Neergaard, Margrethe *Medieval Finds from Excavations in London: 2, Shoes and Pattens*. HMSO, London 1988.

Hughes, Bernard and Therle *Georgian Shoe Buckles*. Greater London Council 1972.

Laver, James (ed) *Costume of the Western World: Early Tudor 1485–1558*. Harrap & Co. Ltd., London, first published 1951.

Laver, James (intro.) *17th and 18th Century Costume*. HMSO, London 1951, 1959.

Ledger, Florence E *Put Your Foot Down*. The Uffington Press, Melksham, Wiltshire 1985.

Malcolm, James Peller *Anecdotes of the Manners and Customs of London during the Eighteenth Century*. Longman, Hurst, Rees and Orme, London 1810.

McDowell, Colin *Shoes - Fashion and Fantasy*. Thames & Hudson, London 1989.

Mazza, *Samuele Armando Pollini – Design e affinità elettive*. Leonardo Arte, 1997.

Pattison, Angela and Cawthorne, Nigel *A Century of Shoes - Icons of Style in the 20th Century*. Quarto Publishing plc, London 1997.

Probert, Christine *Shoes in Vogue Since 1910*. Thames & Hudson, London 1981.

Reynolds, Graham *Costume of the Western World: Elizabethan and Jacobean 1558-1625*. Harrap & Co. Ltd., London, first published 1951.

Ribeiro, Aileen *Dress and Morality*. B.T. Batsford Ltd., London 1986.

Ribeiro, Aileen *The Art of Dress - Fashion in England and France 1750-1820*. Yale University Press, New Haven and London 1995.

Rossi, William *The Sex Life of the Foot and Shoe*. Wordsworth, Ware 1989.

Swann, June *Shoes - The Costume Accessories Series*. General Editor: Dr Aileen Ribeiro. B.T. Batsford Ltd., London 1982.

The Footwear Organiser & Shoe and Leather Trades Export Journal. London: vol. 3, no. 1 (January 1920); vol. 6, no. 6 (December 1921).

The Whole Art of Dress or The Road to Elegance and Fashion. By a Cavalry Officer. Effingham Wilson, Royal Exchange 1830.

Victoria and Albert Museum: 17th and 18th Century Costume. Introduction by James Laver. HMSO, London 1951, reprinted 1959.

Vogue (British edition). Condé Nast Publications, Inc.

Weber, Paul *A Pictorial Commentary on the History of the Shoe*. Bally Shoe Museum, Basle 1982.

Wilson, Elizabeth and Taylor, Lou *Through the Looking Glass – A History of Dress from 1860 to the Present Day*. BBC Books, London 1989.

Wilson, Eunice *A History of Shoe Fashion*. Pitman, London 1969.

Wright, Thomas *The Romance of the Shoe*. C. J. Farncombe & Sons, London 1922.

Index

128

128